MULL AND IONA

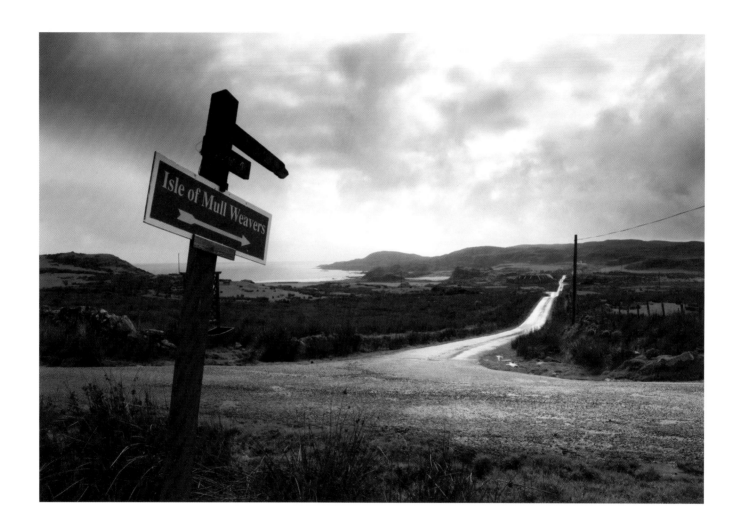

Signpost between Uisken and Ardalanish near Bunessan, Isle of Mull

MULL AND IONA | PHOTOGRAPHS BY
JOHN MACPHERSON | WITH AN INTRODUCTION BY
LORN MACINTYRE

BIRLINN

First published in Great Britain in 2006 by
Birlinn Ltd
West Newington House
10 Newington Road
Edinburgh EH9 1QS

www.birlinn.co.uk

ISBN10: 1 84158 443 6
ISBN13: 978 1 84158 443 0

British Library Cataloguing-in-Publication Data
A catalogue record for this book is available on request from the British Library

Printed in Malta for Compass Press Ltd

PREFACE

In 2004 I was asked by Birlinn publisher Hugh Andrew to photograph a variety of rarely visited West Coast islands from Argyll to Sutherland, which resulted in the book *The Unknown Hebrides*. Although a few of the islands I visited are still inhabited, the vast majority have long ago lost any permanent human population. As a consequence I was often confronted with only the ruins of buildings, crumbling remnants of forgotten communities. The challenge, beyond the physical one of access in often difficult sea conditions, was simply to try to evoke in my photographs some sense of the human presence that had once existed there.

In contrast, this book on Mull and its neighbouring islands focuses on places that are alive, with communities that are thriving, and evolving. So I decided to tackle this project in a more documentary way, to show the islands as best as I could from the perspective of its inhabitants, as well as in the ways that it impressed or affected me. As a West Coast Highlander with family connections to the Ross of Mull, and an awareness of the complications of rural living, housing shortages and seasonal employment, I was keen to reflect some of the effect of such issues on the island residents. I hope this selection of images gives an honest portrayal of place and atmosphere, but particularly of people, during the latter half of 2005.

Photography of people is not without its challenges. I consider it a far more difficult aspect of the craft than landscape photography, and I really enjoy the occasional success of a good 'people picture', because of the effort that's often required to obtain it, but which is rarely evident to the viewer. To confront people and request permission to take their picture can lead to all sorts of outcomes, usually positive. During this project my efforts were warmly welcomed, and I was only rebuffed once, whilst trying to photograph shellfish gatherers on the shore opposite Inchkenneth. It was a fairly amicable fend-off, with teasing comments about 'stealing my soul', but it was very firmly put, so I left them to their labours, unrecorded.

I am often surprised by the number of Highland people I speak to who have never been to Mull. It's a particularly impressive island, with a population of around 2,700. Its landmass covers 300 square miles and it has the distinction of having several smaller and still inhabited satellite islands from which Mull is often regarded as the 'mainland'.

These islands – Erraid, Iona and Ulva – each have their own distinct atmosphere and history. Further offshore, the Treshnish islands, long uninhabited, form one of the most

impressive island backdrops in Scotland, with Bac Mor or 'The Dutchman's Cap' a distinct and well-known feature. These are islands that are very exposed and bear the brunt of the wild Atlantic weather that is so common here. The island of Staffa, and Fingal's Cave, are known world-wide, attracting thousands of visitors each year, that number eclipsed only by the 140,000 people who make the journey to Iona annually. Closer inshore, Inchkenneth and Eorsa ('Horse Island') nestle in Loch na Keal in the shadow of Ben More and are now neither inhabited nor often visited.

Over the last few years domestic tourism has increased in Scotland, and in particular environmental or 'green' tourism. Mull is a big player in this market. It has abundant wildlife: whales, dolphins, otters, seals, and the reintroduced sea-eagles are big attractions. This is good for the rural economy with the b&b's and hotels doing a grand trade during the summer months. However, this popularity has exacerbated one of the real challenges facing rural Scotland, and in particular islands such as Mull: the shortage of housing. Incoming 'islanders' with substantial financial resources, perhaps the consequence of profitable house sales on the mainland, and attracted to the area by its landscape and quality of life, are able to easily outbid resident locals, particularly young families with moderate incomes. A native of Mull told me that house prices on the island increased by 50 per cent during 2005, and that the average price is now £195,000. To put this into perspective, the average annual income for a Mull resident is no more than £15,000. This income will secure a mortgage of around £65,000. Some house plots on Mull are changing hands for £80,000 and upwards.

The Balamory phenomenon alone has had considerable effect in increasing visitor numbers to Tobermory, and raising house prices there. This has affected young islanders in particular; many have left to find employment and higher wages off the island, where house prices are slightly lower. One island native, however, a businessman with some land inherited from his parents, has made a small, personal, but very significant contribution to addressing this imbalance. He has provided plots of ground to several young islanders, fishermen and hairdressers, contemporaries of his own children, and with this simple act of faith has enabled them to put down roots and contribute to the social and economic fabric of their island home.

The European political landscape is changing too, and Poland has entered the EC. Now, as in the wider Highland

area, there are few hotels or pubs on Mull that do not employ Eastern European staff, some seasonal, others permanent, and their considerable skills are in evidence in at least one island farm business where their experience in cheese and meat production is highly valued. One seasonal worker I photographed, Sylwia Warwyk, a trained teacher, was earning four times what she could earn as a teacher in her native Poland, simply by packing boxes on Mull. But this influx of workers has also increased the demands placed on the already strained 'affordable housing' resources.

So Mull is evolving, slowly and inevitably, and despite its problems, the island is thriving in many ways. New arrivals, like Francesca from Sicily and Ricardo from the Azores, have brought considerable skills from their own native islands, and can only benefit our own fair Scottish isle. There are still native Gaelic speakers on the island, and the Gaelic medium education system and the *feis* movement are well supported. But there is another less tangible and perhaps more fragile aspect of our culture that we should pay heed to, one that was brought home to me in the many conversations I had with folk on Mull: our links with our landscape. The family stories about place and events; the vital oral history of time and happening woven throughout each curve of cliff and swell of hillside; the high hill loch where the shepherds lay enjoying lunch and the otter ran past one summer day of infinite stillness, many miles from the ocean; the jagged sharktooth rocks off Iona where the fishermen had a narrow escape one gale-whipped winter day. Each corner of this island has a story; someone knows it, they only need to realise how valuable it is to us all, to our understanding of what makes this landscape truly alive. Mull is undeniably beautiful, but that is only its surface. I think that to appreciate fully the much deeper significance of any landscape, and to truly understand it, you need to know its story. And that's a human story, and for the most part one that's passed on orally. If young people move off, and as older residents pass away, we may lose some of these links with our landscape's social history, and that will diminish all of us.

There are desolate caves along the coast in several places around Mull, and one on Ulva just opposite Inch-kenneth, which you might never visit, and if you did happen to pass it, you would not take much notice of it, but inside have been found shell fragments, evidence of a human presence stretching back 8000 years, of people who once watched the sea as we do, in awe and wonder, and who foraged for its riches. The photo I mentioned previously,

the one I did not take, of the shellfish gatherers opposite Inchkenneth, I will describe for you: several people in colourful warm clothing bent double amid a sea of kelp, plastic pails beside them. In front of me, separating me from the gatherers, two prams, pushed and carried with difficulty across the slimy weed and rocks. One had a baby's bottle fastened to the handles, half-full of milk, and the well-fed baby slumbered happily behind a screen of plastic. I did not take the picture, but I recall it vividly and so dearly wish that I had done so. If I had taken that image would I have stolen their souls? I think not. But I would have captured a wonderful and quite exquisite moment of place and of people, and above all a moment of tradition, a link to our past, one that has a long history in coastal and island Scotland: the sea providing, the people receiving. '*Aig an oir*' – at the edge.

I have photographed many other scenes since that particular day, and many people, islanders new and old. I have not captured their souls either, for cameras cannot do such a thing. I feel I have, however, recorded a few moments in time in their lives, and been welcomed in doing so. But I would like to think I have also captured some fleeting glimpse of the soul of their place, the place they call home.

I'd like to thank the many islanders who assisted in the making of this book. In no particular order: on Erraid, thanks to Paul, Debbie, Josh, Zehra, Richard, Vrede and your guests for the warm welcome, particularly Sam for your permission to intrude when you were so busy cooking. On Ulva, The Low family, especially Ruby for posing so happily, and Sheena for the tea and the blether; to Barry George for the opportunity to photograph you as you worked. On Mull itself many thanks to Robert Leitch Snr and Robert Jnr from Lagganulva Farm and your able assistants Nick Cumming-Bruce and Sam Scott; to Jamie MacLean, Ruaridh Allan and Steven Daly for sharing the 'excitement' of your afternoon on Salen main street in the rain; Alastair ('Addy') MacQuarie, Rose Cottage, Salen; a big thank you to John and Serena Coyle, and your extended family at Mediterranea, particularly your mum Francesca for posing so elegantly in the full glare of Salen main street; Andy Duffy and Steve Cordingley of 'Scottish Sea Farms'; the Qureshi family, Viresh and Reena Kumawat, and Chandrajeet Yadav for standing still in a deluge while I faffed with the camera; Pat and Hazel at Arle Lodge; Chris and Jeff Reade at Sgriob-Ruadh Farm; Joe Reade, Ricardo Raposo and the staff at Island Bakery. Thanks to Sam and Mickey Duffy at Torlochan for the tea and conversation on a slow

photo day when I needed some inspiration; and to Iain and Pat Morrison of Turus Mara for the trip to Staffa, and the local contacts. A big thank you to Lachlan and Chrissie MacLean and son Donald at Knock Farm for welcoming me into your new home, and to Lachie Jnr for help in arranging this.

And thanks also to Ronan Daniel Martin, Kenny Turnbull and his dad Nick, and Colin Morrison, for letting me intrude on your crab packing in the pre-dawn dimness at Croig when you were all utterly exhausted. I hope I have done your island justice with my photography. As always, warm thanks to Hugh, Jim, Liz, Andrew and Laura at Birlinn for the opportunity to undertake this project, and to Melanie and Corrie the dog, at home, for constant encouragement.

John MacPherson

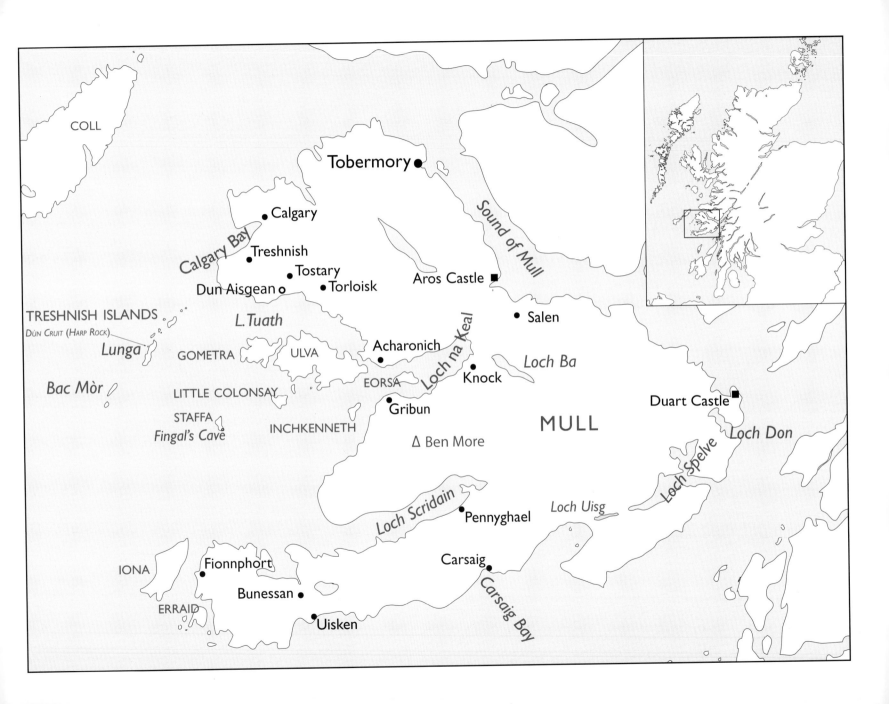

COLL

Tobermory

Calgary

Calgary Bay

Treshnish

Tostary

Dun Aisgean

Torloisk

Aros Castle

Sound of Mull

TRESHNISH ISLANDS

Dùn Cruit (Harp Rock)

L. Tuath

Salen

Lunga

GOMETRA

ULVA

Acharonich

Loch na Keal

Loch Ba

Bac Mòr

LITTLE COLONSAY

EORSA

Knock

STAFFA

Fingal's Cave

INCHKENNETH

Gribun

MULL

Duart Castle

Loch Don

Δ Ben More

Loch Spelve

Loch Scridain

Loch Uisg

IONA

Fionnphort

Pennyghael

Carsaig

Bunessan

Carsaig Bay

ERRAID

Uisken

INTRODUCTION

My family migrated from Oban to Tobermory on the isle of Mull in 1959, when I was a teenager. We crossed on the *Lochinvar* on a calm day and were able to sit out on deck, admiring the mountains of our new home. The treacherous cat we had brought across in a box defected on that first day, and spent the rest of her long and luxurious life stretched out among the Iona crosses and miniature Spanish galleons of Daisy Craig's Treasure Shop next door.

My father Angus had been appointed manager of the Clydesdale Bank in Tobermory. The bank house, with the offices below, was a Scottish Baronial mini-castle with battlements and a tower, spacious to allow four sons to sprawl. Its position allowed us a panoramic view along Main Street, and across the bay. The town had been founded by the British Fisheries Society (Governor, the Duke of Argyll) towards the end of the eighteenth century, but the expected shoals had failed to materialise in the surrounding waters, and over the years, though it had a small fishing fleet, Tobermory became principally a tourist place visited by the steamers.

Mull was nirvana for my father because he could use his Gaelic, and over the years would become obsessed with the language. In those days there was still a considerable number of native speakers on the island, particularly among the elderly. There was one monoglot Gael in Tobermory at that time, but we never had the honour of meeting him or her.

My father liked nothing better than to sit over a tray of tea and biscuits in his office, listening to an old woman's *sgeultachd* (lore), though she hadn't a penny on deposit. The irate landowner demanding an interview to increase the overdraft on his already bankrupt property had to wait while the protracted tale was concluded next door.

My father took over a cine camera from a customer who couldn't pay the higher purchase commitment. He stood in the tower extension to our sitting-room, a panoramic vantage point looking along Main Street, winding the key of the clockwork camera. We still have scores of films, a precious archive of the island in the 1960s. How many times did he film the lit clock on its granite obelisk erected in memory of the intrepid Victorian explorer Isabella Bird, who had a house in the burgh? In this film, now showing on my wall, smoke rises from now defunct chimneys, and an old Austin, a Ford Consul and a Mini are parked at the kerb, years away from the busy place recorded by John MacPherson's camera for this book, with parking now at a premium.

Were the properties on Main Street painted in these different brilliant colours when I was a youth at that window?

My father's films confirm that some of them were, but there were houses with grey exteriors, behind which were hovels. We used to go with my father to help him clear out the habitations of deceased customers for whom he was executor. There didn't seem to be anything of value, until my father picked up a black disk of Neil Maclean singing *An T'Eilean Muileach* ('The Isle of Mull'). He put it on the old wind-up gramophone and we had a ceilidh while we filled the rubbish sacks with skeins of plus-fours and corsets that looked more like body armour.

On a summer evening we had the windows open on the balmy bay and heard the rumble of an anchor spilling where the Spanish galleon lies, blown to smithereens by the booty-hunters in search of ducats down the centuries. I find these memories of Tobermory so enhanced by John MacPherson's photographs that they bring tears to my eyes: Bobby MacLeod's yacht *Starletta* coming in at dusk, his accordion stowed below after the maestro had played at a ceilidh out in Barra. I hear again the sound of seaboots being shed in the well of our staircase, and people from Glasgow coming up with several bottles to have a dance with my father.

But it wasn't all romance. We went along to Ardmore to locate among the bracken the ruins of homes that had been cleared on the Glengorm estate by the hated James Forsyth. He is reputed to have asked an old woman to suggest a name for his new castle, and she proposed Glengorm. He didn't know that the translation from Gaelic, 'the blue glen', was to keep alive the memory of the smoke from the burning homesteads, and not an ethereal mist.

We had a car, which meant evening and weekend excursions throughout the island. Again the photographs in this book stimulate memory. The boats drawn up on the beach at Salen seem to have been deteriorating there for half a century. Beyond Salen is a stretch of road known to islanders as 'the Gruline Free,' where my father could put down his foot, to the terror of the occupants of the car. We are now travelling (my mother with her eyes closed) the road under the dangerous majesty of Gribun's cliffs. Below is the island of Inchkenneth, retreat of the tragic Unity Mitford, retarded by the bullet she put in her head in a Munich garden on the Sabbath morning that Britain declared war on her beloved Führer. Beyond, the fertile island of Ulva, cleared of hundreds of inhabitants following the potato famine by the brutal Francis Clark, the poignant beauty of its deserted landscape caught by John's camera.

Fionnphort is the terminus of the Ross of Mull

road, the place for the ferry to Iona, and a departure point for Staffa, on which I have stayed, kept from sleep by the clamour of roosting seabirds.

One of my favourite views on Mull is on another excursion, westwards from Tobermory, to the steep descent to the village of Dervaig, with its pencil church steeple and neat cottages, another place to stop so that my father could hear impeccable Gaelic from the MacLean salmon fishing brothers. I recall a festive season visit to Quinish House, where Major 'Scrap' Balfour Paul, my father's charming friend, showed us a christening robe lying on a bed. It had been ripped in two, as if by a giant claw in that supposedly haunted mansion. On Sunday afternoons in summer we went to swim at bracing Calgary Bay, which gave its name to the Canadian town.

My father was always reluctant to leave Mull, even for a night, so on trips to the mainland to shop or visit relatives, we had to get the evening boat back. There were nights of storm on the *Lochinvar*, when Captain Black's seamanship and that of the crew saved us from being wrecked. My mother would be lying moaning on a couch below, while my father sat in the bar with his farming clients, dogs dozing at their boots while the glasses slid on the tables, as if moved by spirits anxious to communicate.

Then, in 1962, the car ferry came to Craignure, and Mull changed overnight, with long lines of tourists' vehicles on the single track roads and the doctor pumping his horn, trying to get to an emergency. Cottages which couldn't sell in the 1950s were snapped up as holiday homes at big prices, and kit houses began to appear on crofts where my father had leaned over fences on summer evenings, conversing in Gaelic with the crofter while his dappled cattle stood knee-deep in the sunset. Silversmiths and other craft workers moved on to Mull, and a rally roared through the forests. My father's black homburg never seemed to be off his distinguished head as he attended the funerals of the last of the Gaelic tradition bearers. He wouldn't retire to the mainland, but every evening went down the stairs to occupy a chair in Margaret MacDonald's shop, and behind locked doors would spend a blissful hour reminiscing in Gaelic about the island with Margaret and her brother Calum. My father said that he had never heard better Gaelic in his life from these two dear friends who embody all that is worthy about Mull folk.

When I go back to Tobermory now I look up at the tower window of the bank house, and imagine my father standing there, filming unsteady customers emerging from the Arms, though he is twenty years dead. The elegant lady

with the shopping basket and little dog in front of me is my
mother, also among the departed. My late brother Kenny
jogs past on his way up to the games field, to break another
record, past the new football pitch dedicated to his revered
memory. Passing the Mishnish Hotel I imagine I hear Bobby
MacLeod composing 'Jean's Reel' for his wife, both gone
also. And here comes the ghost of the genial 'Pibroch' Mac-
Kenzie, fiddle virtuoso in his houndstooth jacket.

 But one cannot live among the dead. Mull has a
new vibrancy now, thanks in part to Balamory, the children's
television serial, and to those enterprising people who have
come from the mainland to set up new businesses, from
whale watching to weaving. John MacPherson's photographs
celebrate the essence of the old and new on an enchanting
island.

Lorn Macintyre
January 2006

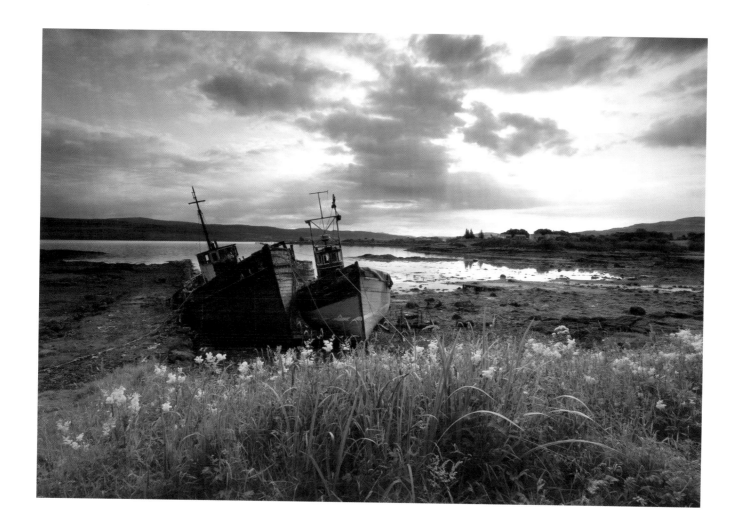

Old fishing boats on Salen beach, Isle of Mull, awaiting renovation and repair, bathed in early light on a calm summer morning

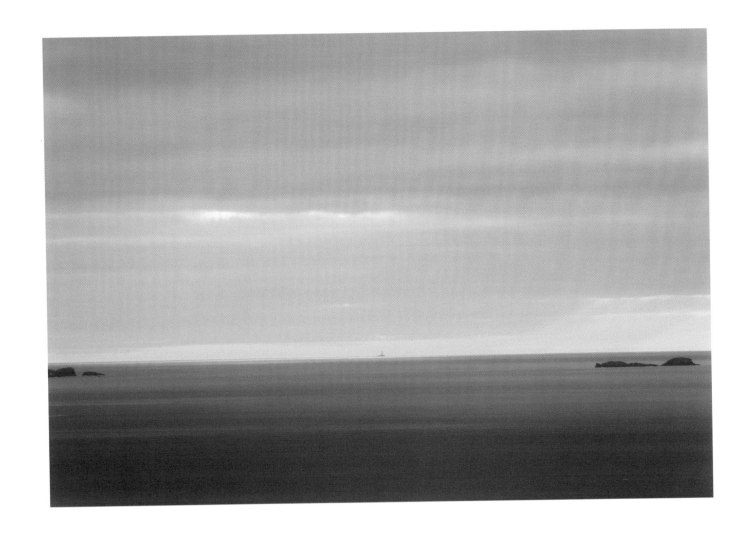

Skerryvore lighthouse stands proud on the western horizon. Built of Mull granite in the six years from 1838 to 1844 this splendid example of Alan Stevensons engineering prowess stands 156 feet high and is regarded by some as the worlds most graceful lighthouse.

Tobermory main street is very colourful and many of the shop signs add to the atmosphere

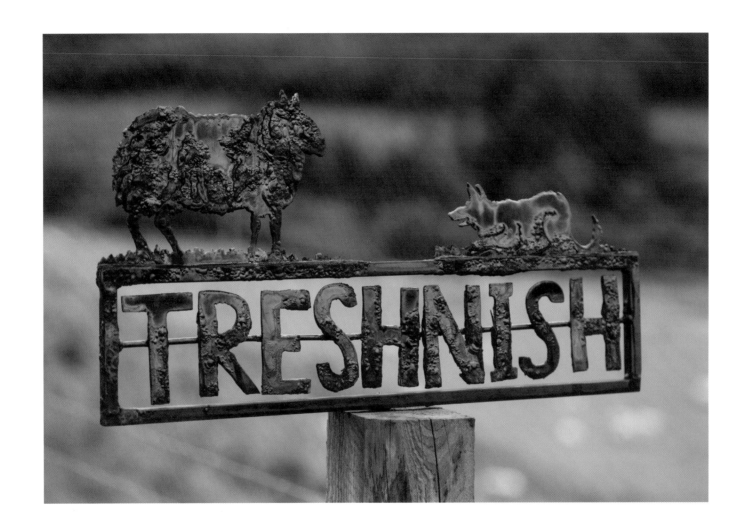

The well-weathered and rusting sign for Treshnish Farm, Isle of Mull, gives a huge clue to the type of livestock the farmer works with

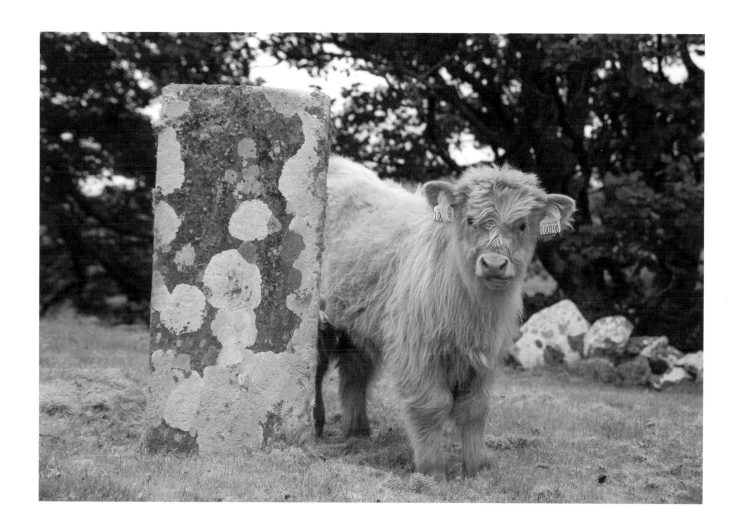

A herd of Highland cows had managed to break into the graveyard of Kilninian Church at Torloisk on Mull and were in danger of pushing over the old headstones. With the help of an American visitor we rounded them up and drove them out. I took a picture first!

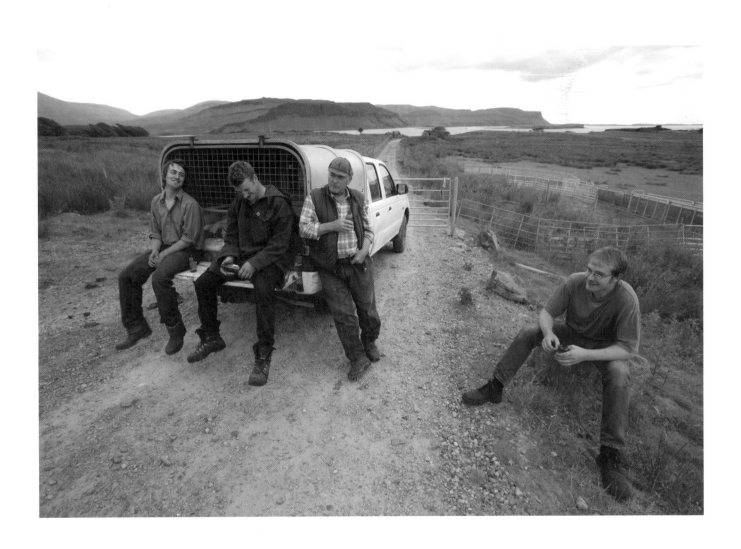

Nick Cumming-Bruce, Sam Scott, Robert Leitch, Sr and Robert Leitch, Jnr relax with a beer after a hard afternoon working the sheep on Lagganulva Farm, Isle of Mull

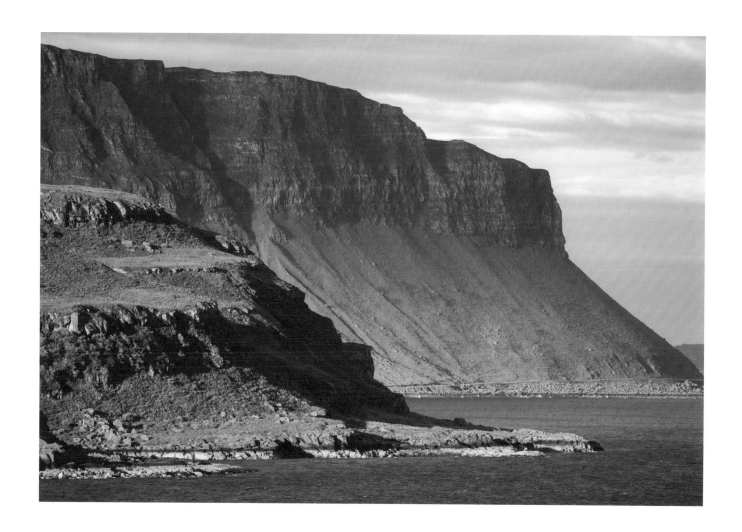

Eorsa (Horse Island) catches the sun with the spectacular cliffs of Gribun behind (Loch na Keal)

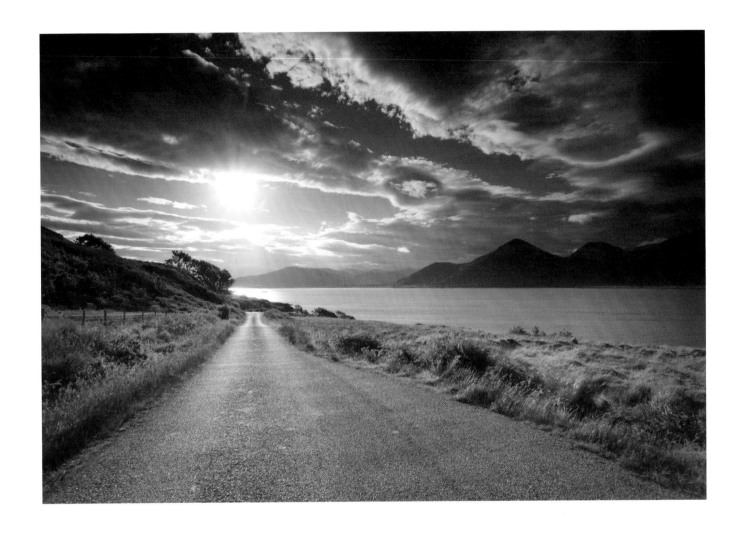

The view up Loch na Keal, Isle of Mull, from Killiemor, on an idyllic summer morning

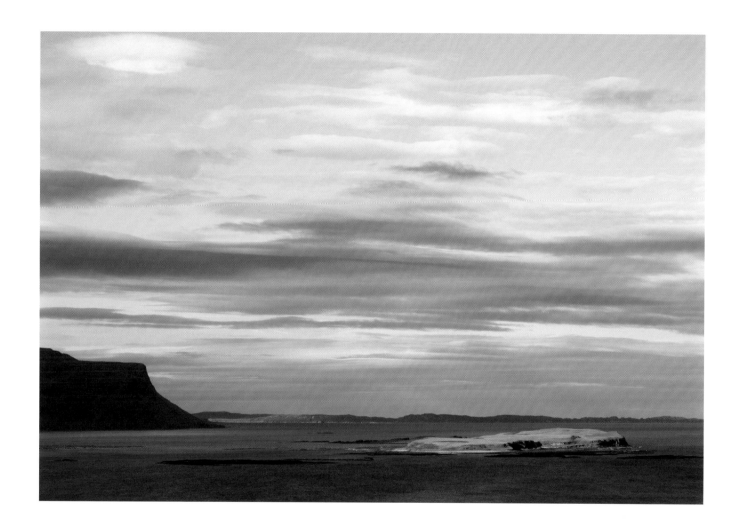

Sunlight illuminates the lush green of Inchkenneth Island, burial place of several Highland clan chiefs, in Loch na Keal

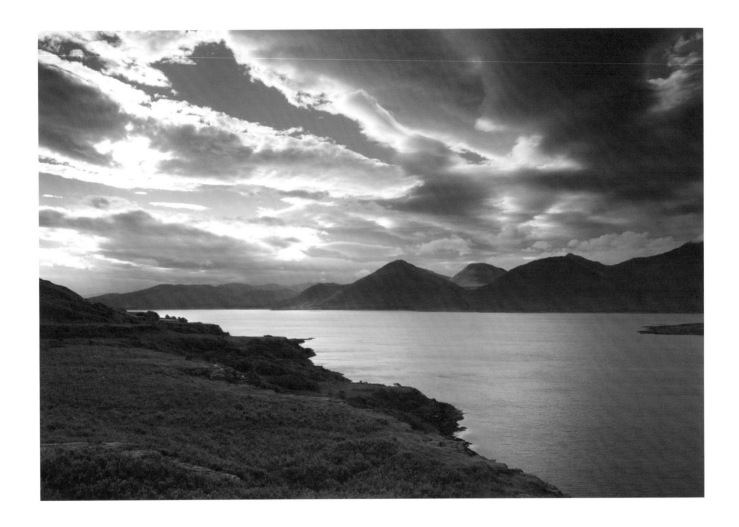

Morning light and dramatic clouds over Ben More and Loch na Keal, Isle of Mull

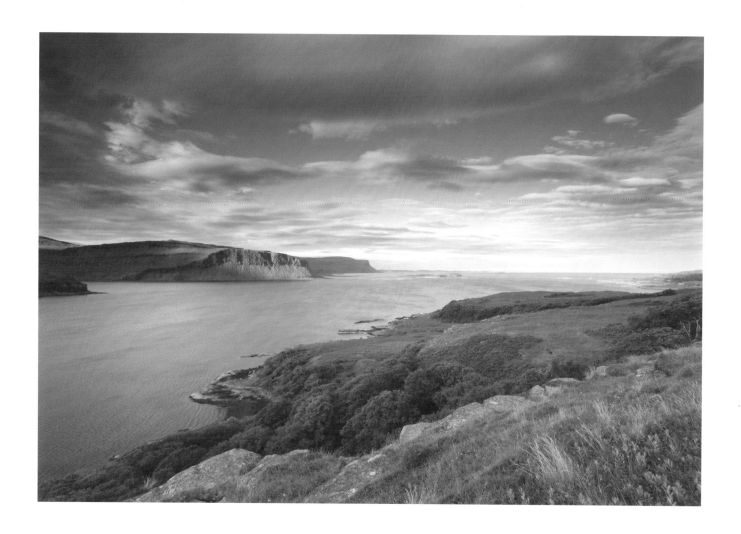

A wonderful Mull panorama, with Eorsa just intruding into the frame, the Gribun cliffs sunlit to the left, and across the frame, Inchkenneth, and Ulva to the right. Far behind the Ross of Mull lies low on the western horizon.

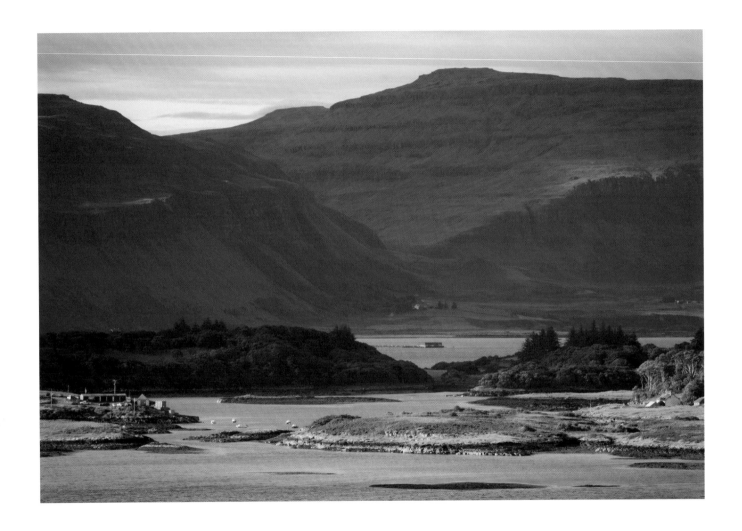

A view across the Sound of Ulva and Ulva to the cliffs of Gribun and Balmeanach behind

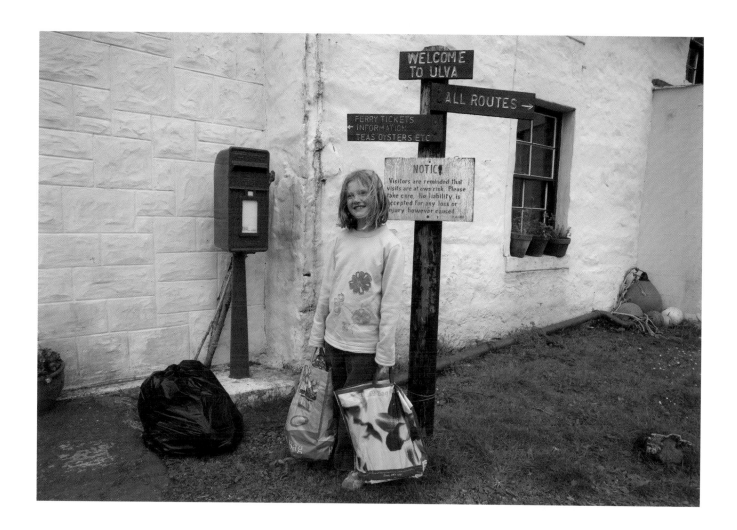

Ulva resident Ruby Low had just returned from a visit to Mull staying with her school friend Isobel, and happily posed for me beside the tearoom her parents run

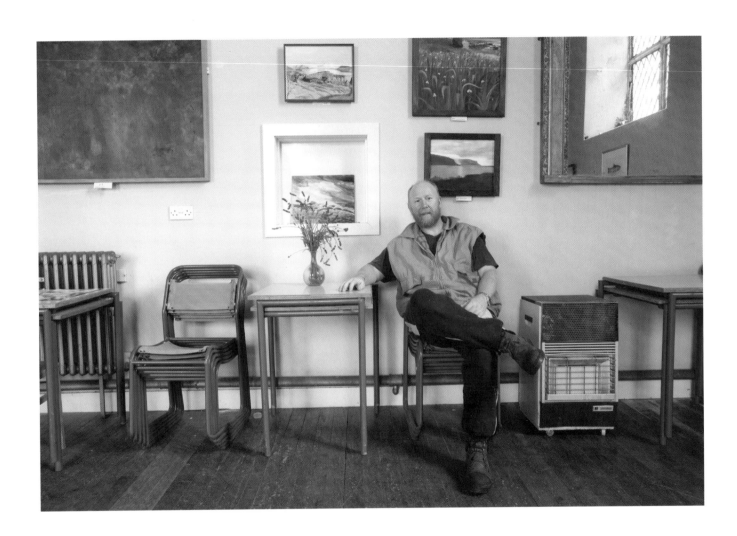

Ulva resident Barry George was refreshing the wild flower display in the church hall on Ulva and was pleased to pose for me in the wonderfully soft light of the interior

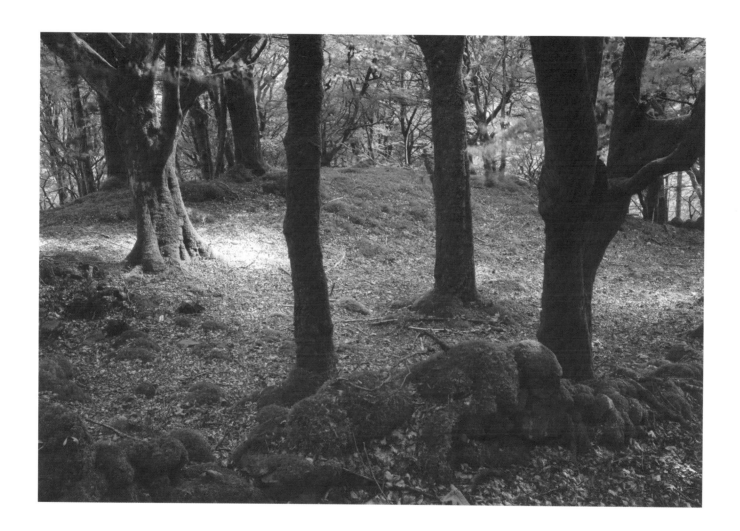

The woodlands on Ulva are lush and impressive. I captured this shaft of light as it spilled through, illuminating the woodland floor near Ulva House.

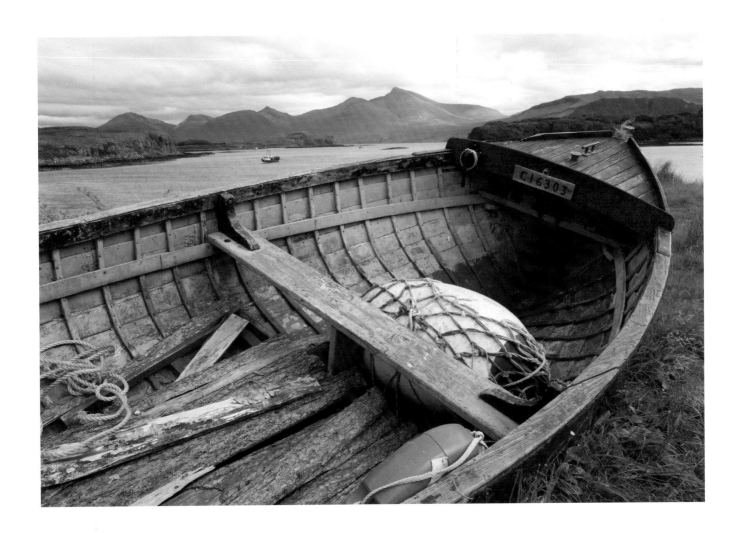

A wooden boat pulled high up on the shore makes an ideal foreground for a photograph across the Sound of Ulva towards Ben More

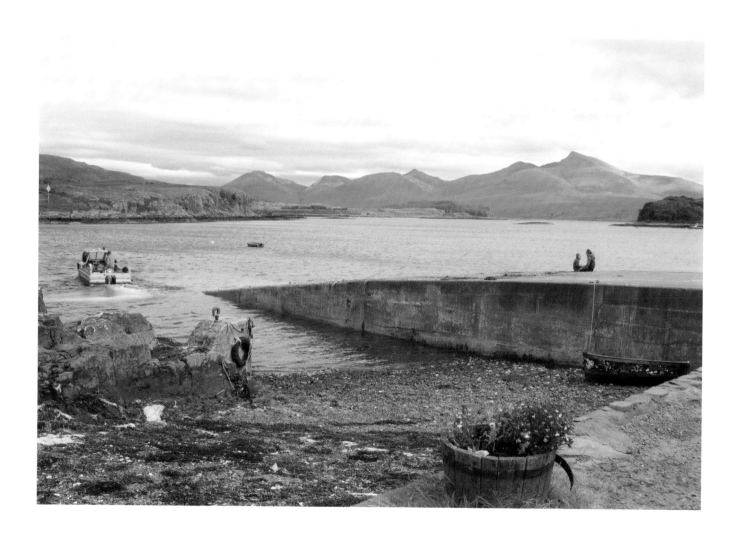

Ruby Low and a friend play on the jetty on Ulva, with the unmistakable bulk of Ben More behind. To the left the Ulva ferry begins its short crossing of the Sound of Ulva.

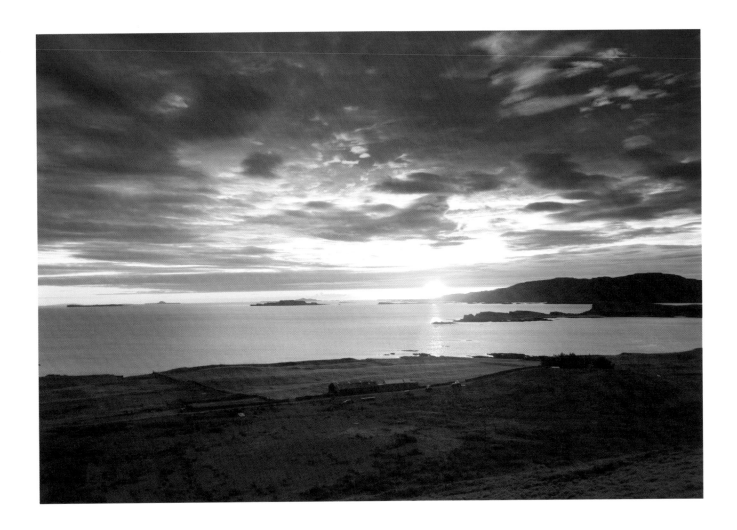

The sun sets in summer over the Treshnish Islands and Gometra from the hills above Balmeanach, Isle of Mull

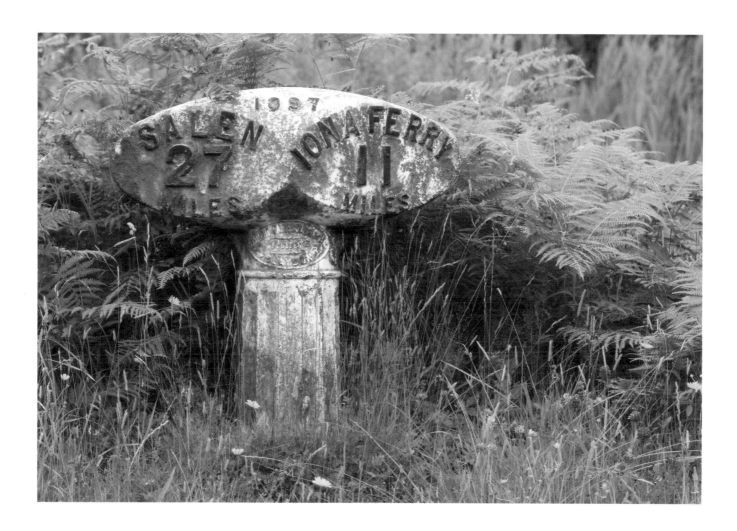

A milepost between Salen and Fionnphort rusting in the salty Atlantic air

Ceilidh dancing practice for some of the participants in a football tournament held at Bunessan, Isle of Mull

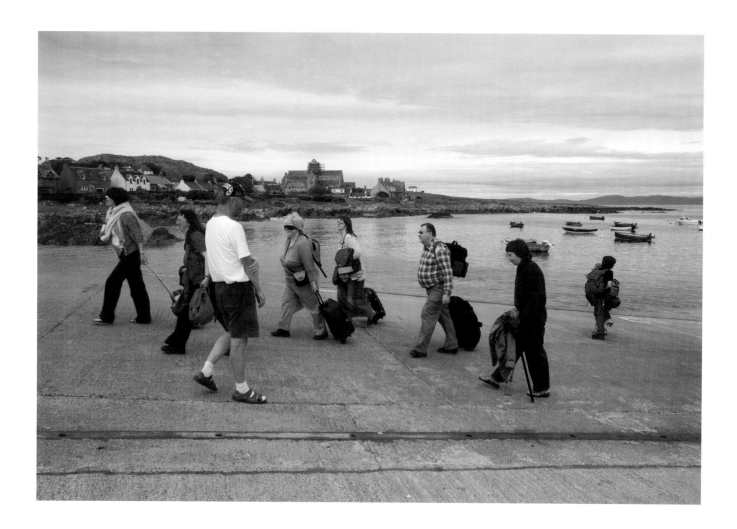

Visitors arriving on Iona from the ferry, with Iona Abbey in the background

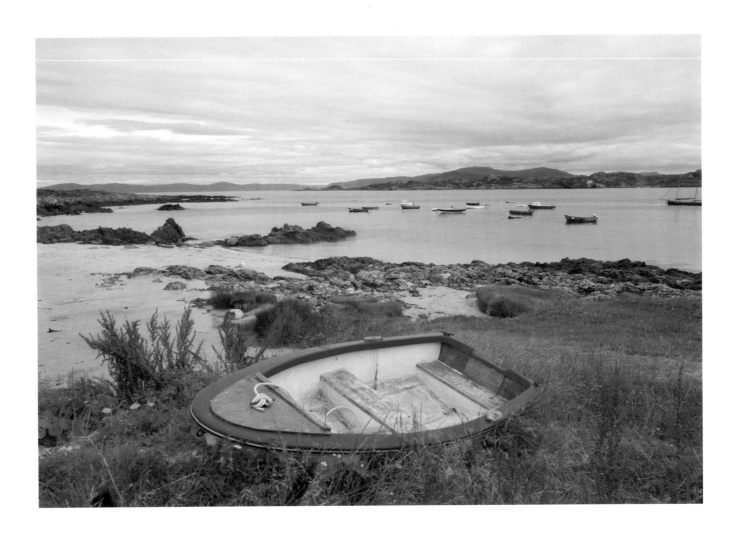

A peaceful afternoon of limpid water that gently rocked the boats moored on St Ronan's Bay on Iona

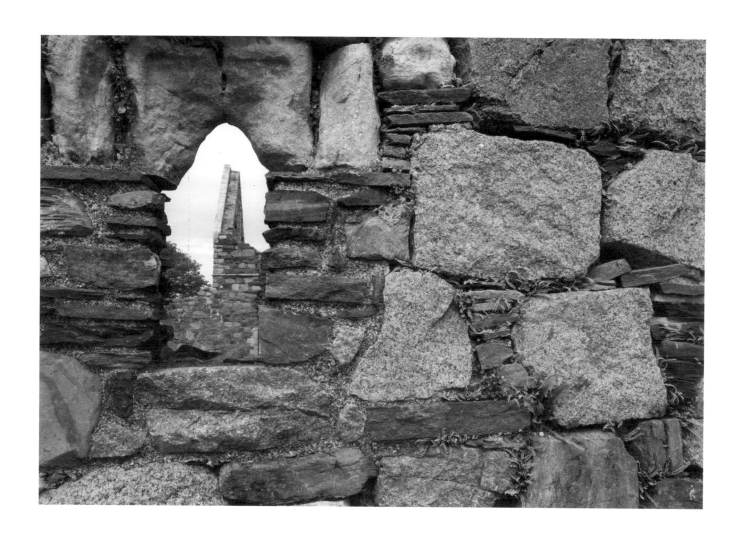

A close-up of the fine granite stonework in the walls of the nunnery of St Mary with the gable of one of the Nunnery buildings visible behind through a weathered window, Iona

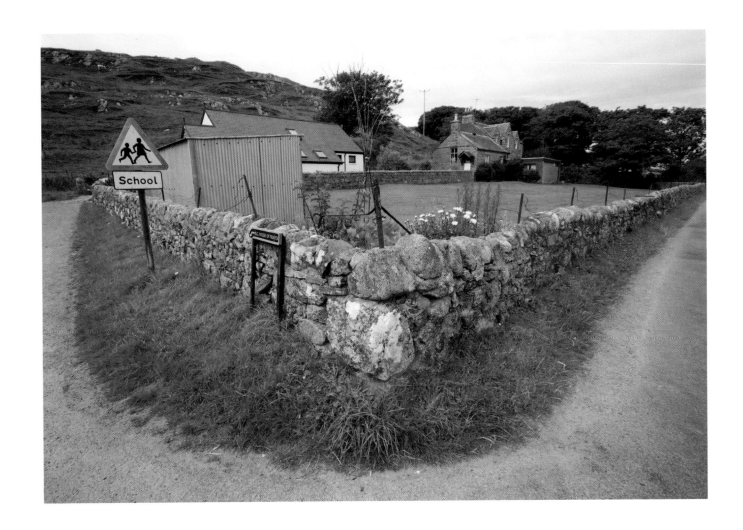

Iona primary school with its fine stone dyke surrounding the playing field

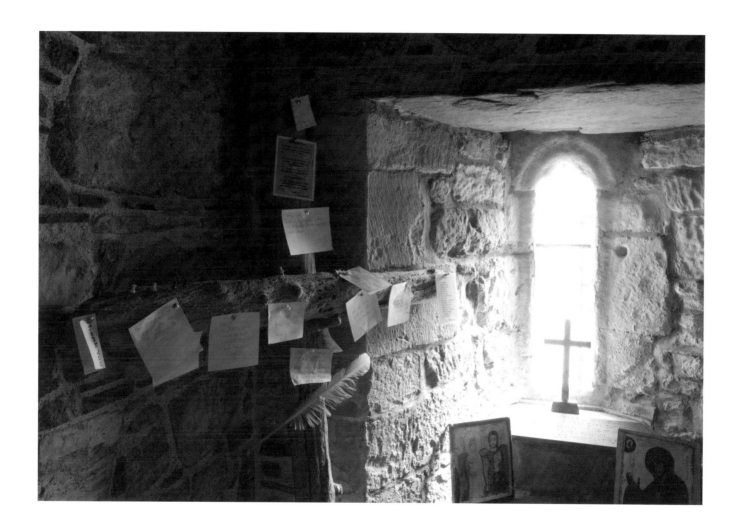

There is a 'Quiet Corner' in Iona Abbey where stands a wooden cross, and visitors have left many devotional messages pinned to it. The beautiful side lighting spilling in adds to the tranquility of the place.

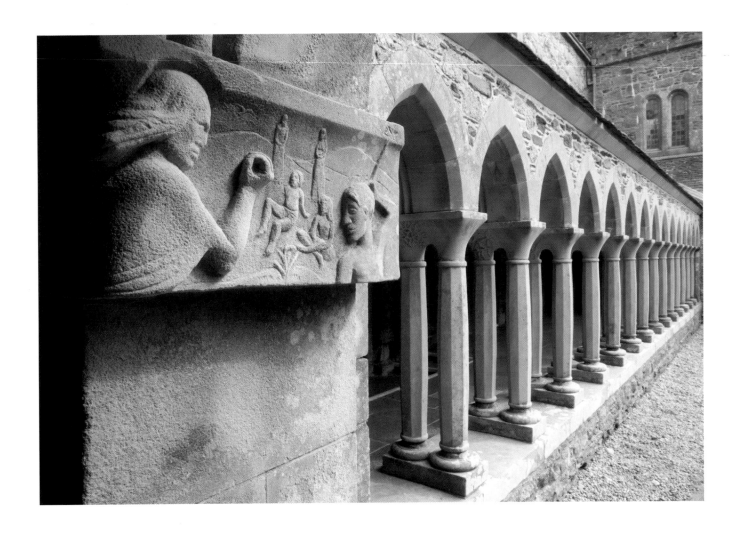

Sheltered by the bulk of the Abbey, the cloisters within Iona Abbey are a peaceful haven, even on a day of cool winds. The fine stonework is worthy of very close inspection, such is the quality and detail in the carving.

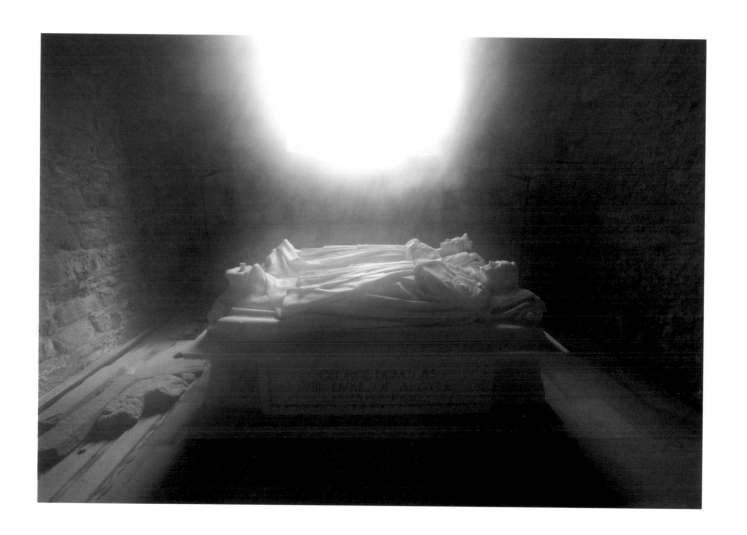

Inside Iona Abbey is the tomb of George Douglas Campbell, 8th Duke of Argyll, 1823–1900. With the light spilling in through the window behind, it is a very atmospheric corner.

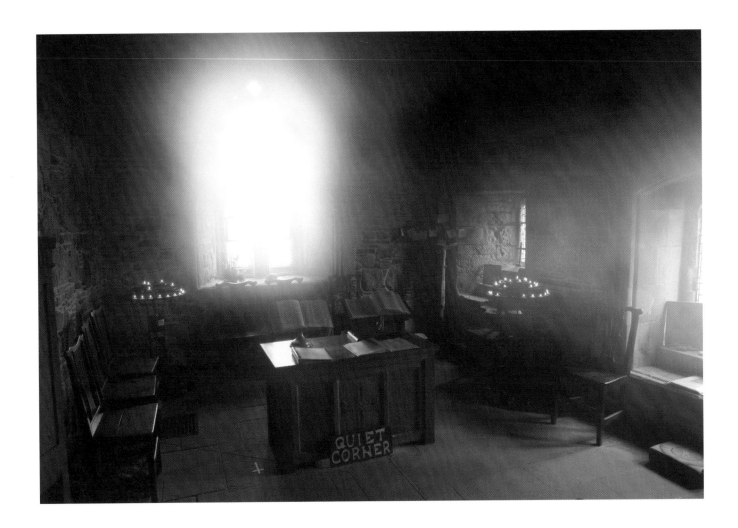

A wonderful mixture of candlelight and soft daylight illuminates the 'Quiet Corner' in Iona Abbey.

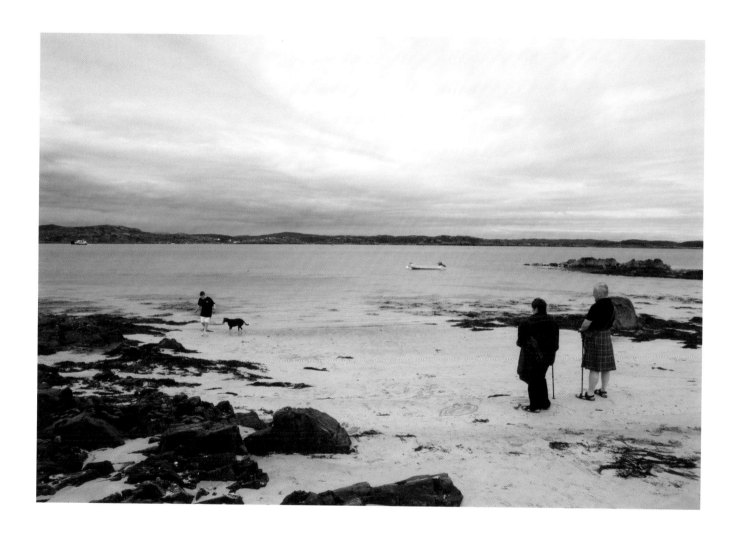

A summer visitor to Iona, resplendent in his kilt, with his family on the beach at Port nam Mairtir (Martyr's Bay) on a warm summer afternoon, looking across the Sound of Iona to Fionnphort on Mull as the ferry approaches

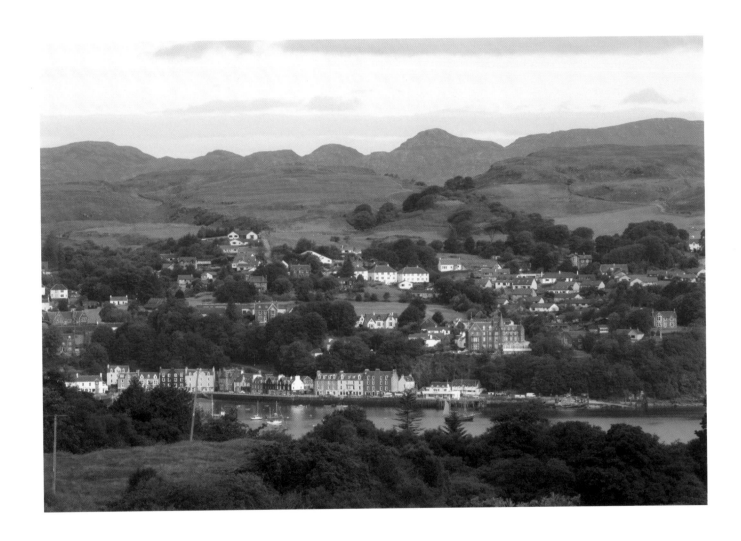

The terraced houses of Tobermory village, Isle of Mull, with the hills of Ardnamurchan visible in the background

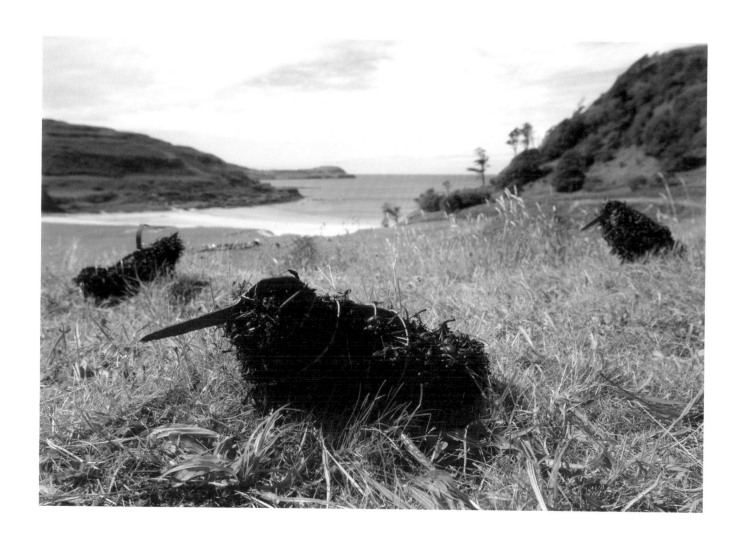

There's a woodland arts installation, Calgary Art in Nature, at Calgary Bay, and as you wander through you encounter all manner of delights. These are oystercatchers fashioned from bits of metal and a pile of dry seaweed.

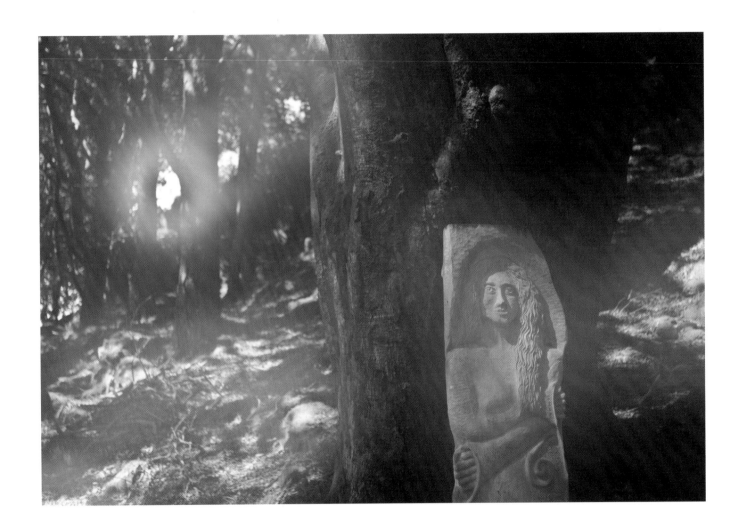

One of the pieces in Art in Nature at Calgary is this wonderful piece of woodcarving by Lisa McKenna. Lisa works in Calgary Hotel during the summer season and is learning woodcarving under the tutelage of Matthew Reade.

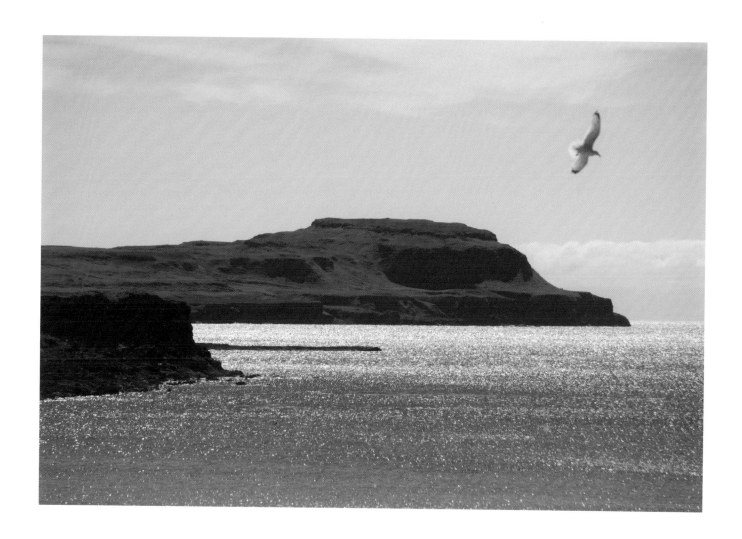

A perfect summer day of calm seas and wheeling gulls over Calgary Bay, Isle of Mull, with Treshnish Point behind

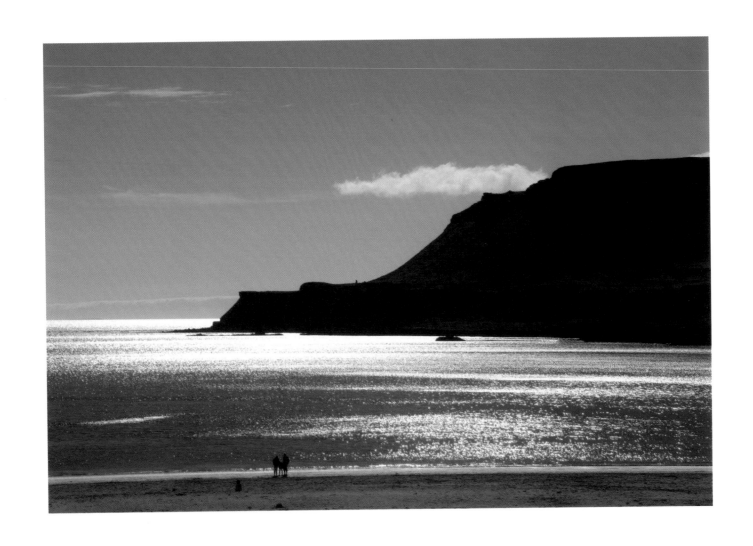

Visitors enjoy a tranquil summer day of crystalline light at Calgary Bay, Isle of Mull

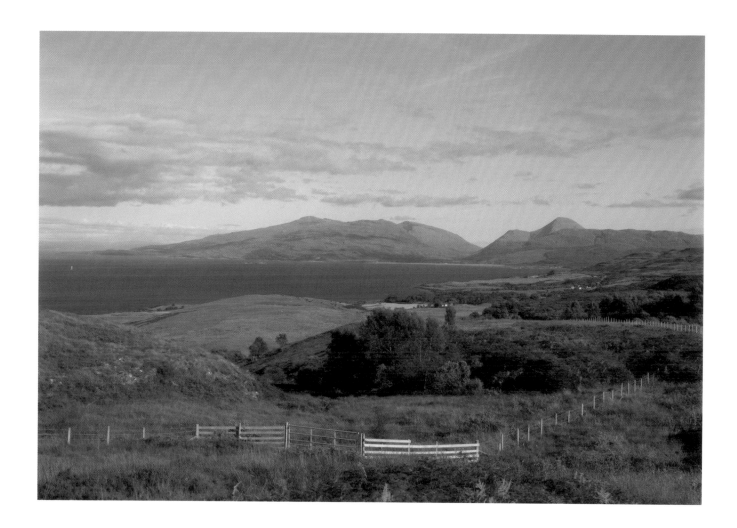

The view down the Sound of Mull, looking south towards Glen Forsa just beyond Salen Bay and village, Isle of Mull

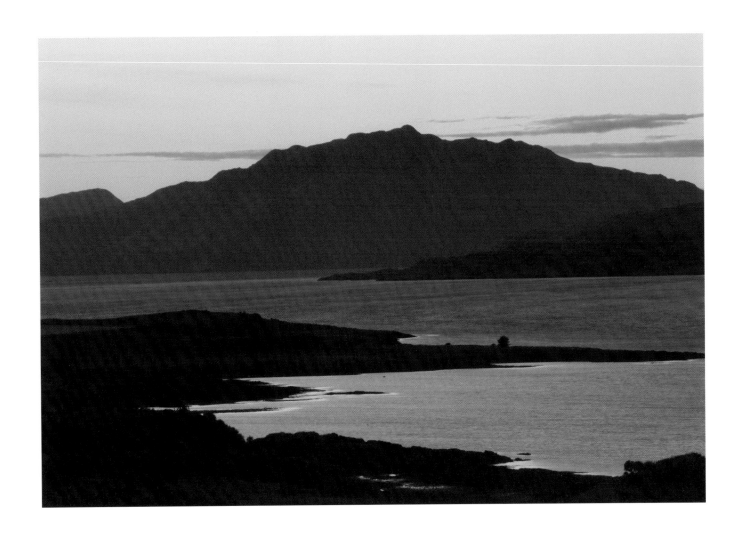

Evening light over the Sound of Mull, looking past Auliston Point towards Ben Hiant on Ardnamurchan peninsula, the most westerly point on the Scottish mainland

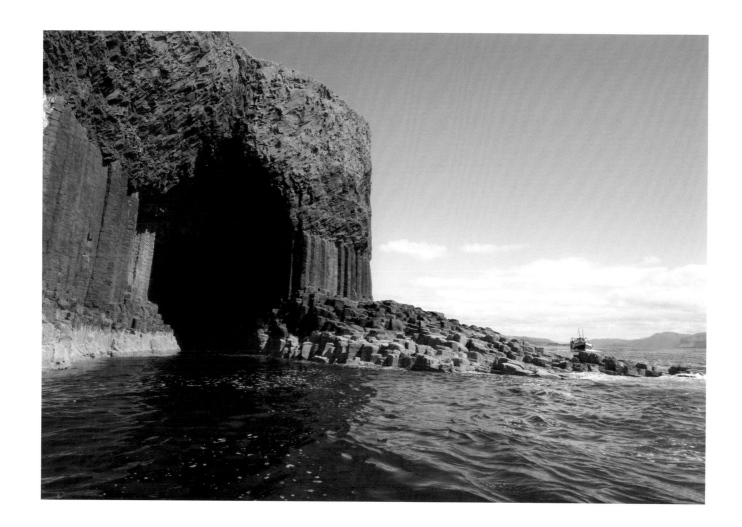

Fingal's Cave on Staffa viewed from the sea on a day of pleasant swells and warm air

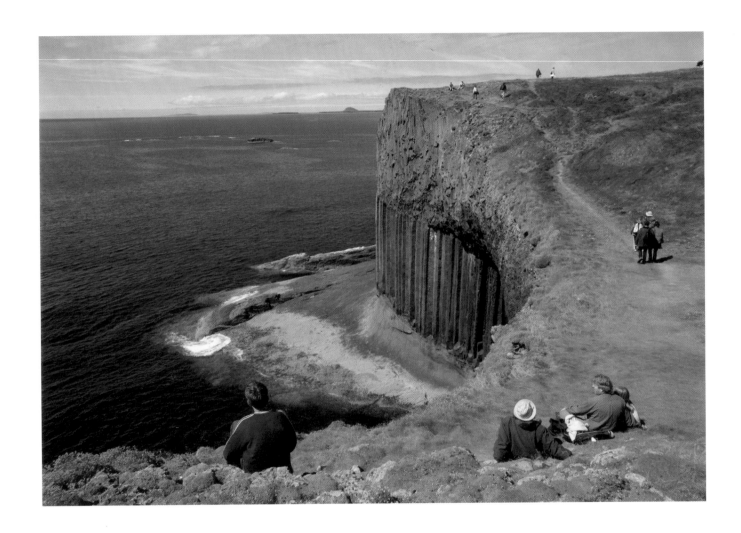

Summer visitors wander the cliffs above Fingal's Cave, Staffa. Bac Mor (Dutchman's Cap) is visible on the horizon.

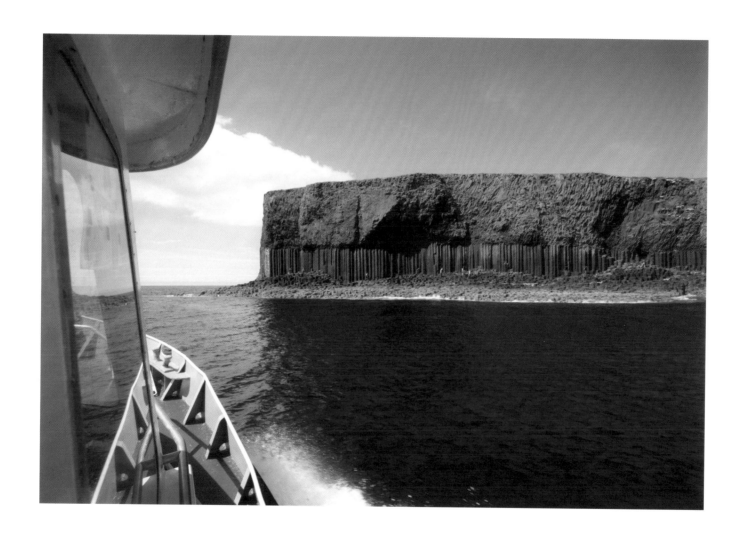

Approaching Staffa on a calm and warm summer day

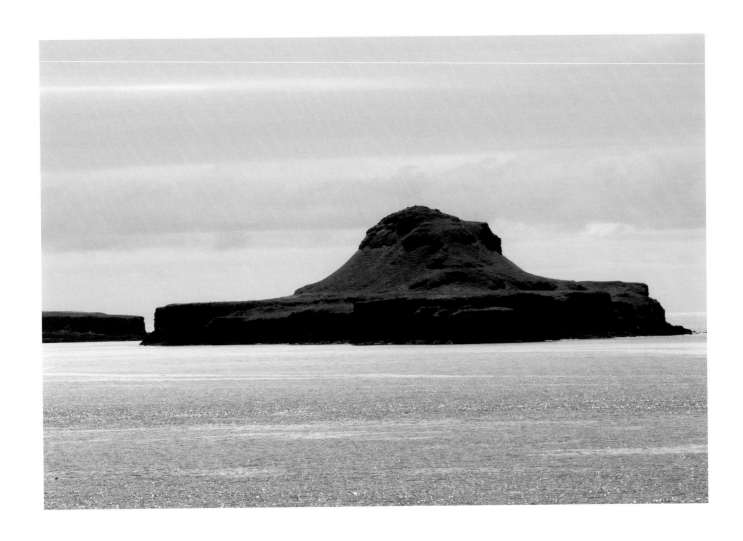

Bac Mor, or as it is more often known 'The Dutchman's Cap', with Bac Beag visible behind, viewed from Lunga, Treshnish Islands

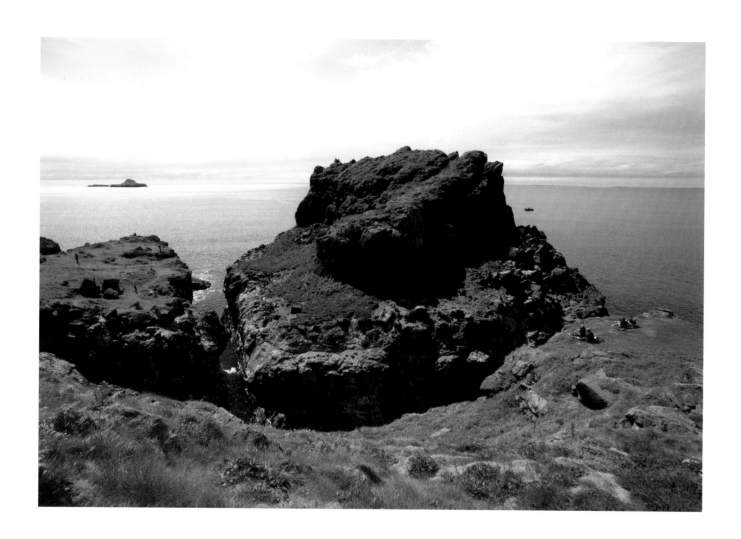

Dun Cruit (Harp Rock), off Lunga, is a popular spot for day visitors. Numerous seabirds nest on its steep cliffs, and fisherman used to crawl across a wooden spar to reach the nests and remove the eggs for food. Lunga.

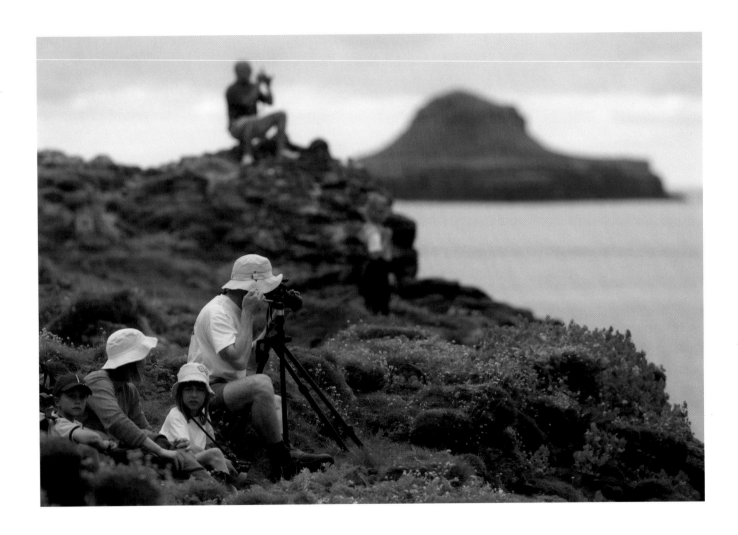

Visitors watching the seabird action on the cliffs of Dun Cruit (Harp Rock), Lunga, with Bac Mor visible behind

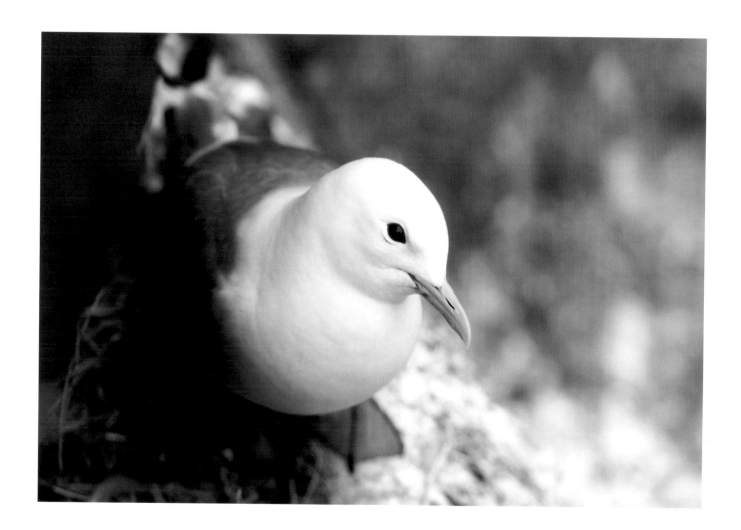

Nesting kittiwake on the steep cliffs of Dun Cruit (Harp Rock), Lunga

A riot of late summer vegetation covers one of the more sheltered corners of Lunga. On the horizon from left to right lies the low landscape of Coll, the bulk of the Rum Cuillin and tiny Muck with its near neighbour Eigg. Barely visible between Rum and Eigg the rugged peaks of Skye jut skywards. A stunning vista.

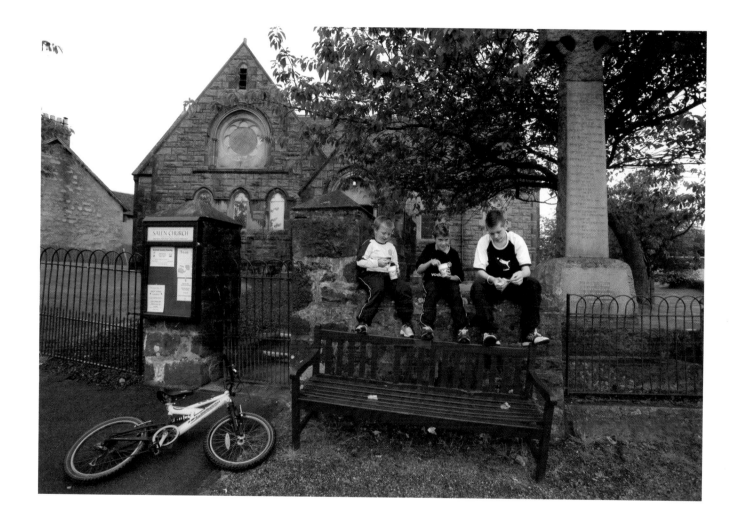

Jamie MacLean, Ruaridh Allan and Steven Daly watching the world go by and enjoying a Pot Noodle on a damp but warm summer day on Salen main street, Salen, Isle of Mull

The Atlantic oakwoods along the west coast of northern Scotland are a wonderful and little explored habitat. Mull is fortunate in having several areas of lush oak woods, such as this one along the side of Loch na Keal, near Knock.

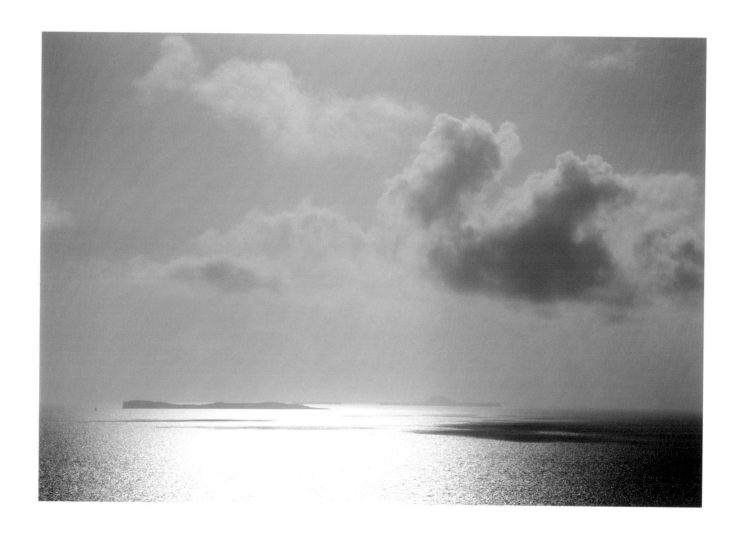

A lone yacht passes the western side of Staffa, with Bac Beag and Bac Mor behind, on a warm summer day of sunshine and cloud

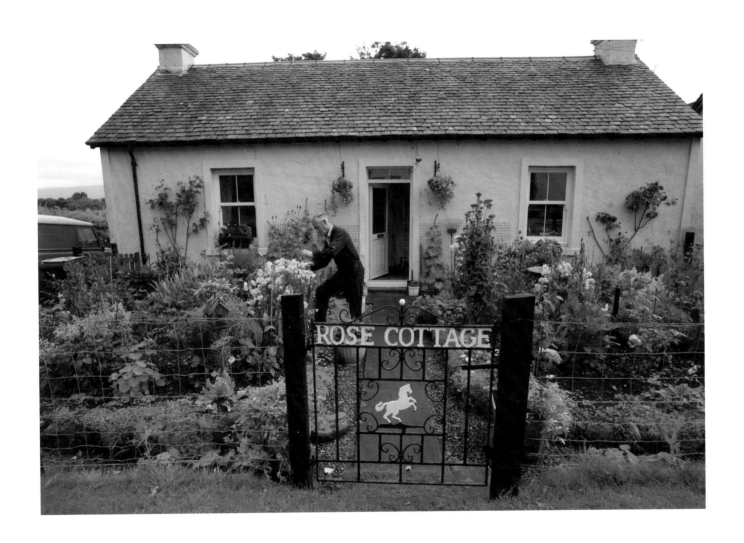

The lush climate of the Sound of Mull makes Alastair ('Addy') MacQuarie's well-tended garden flourish (Rose Cottage, Salen, Isle of Mull)

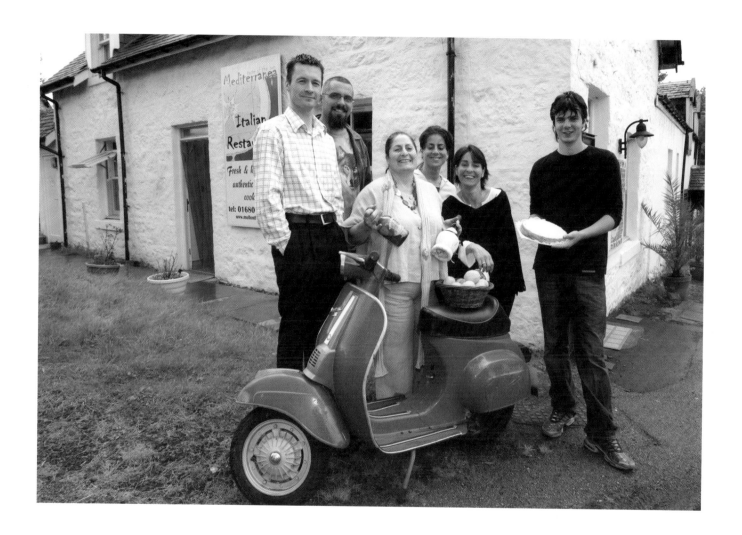

John and Serena Coyle and their extended family own and run a very fine Italian restaurant, Mediterranea, in Salen, ably assisted by Serena's mum, Francesca. Bottles of Chianti and Tobermory whisky symbolise the cross-cultural links between Sicily and Salen.

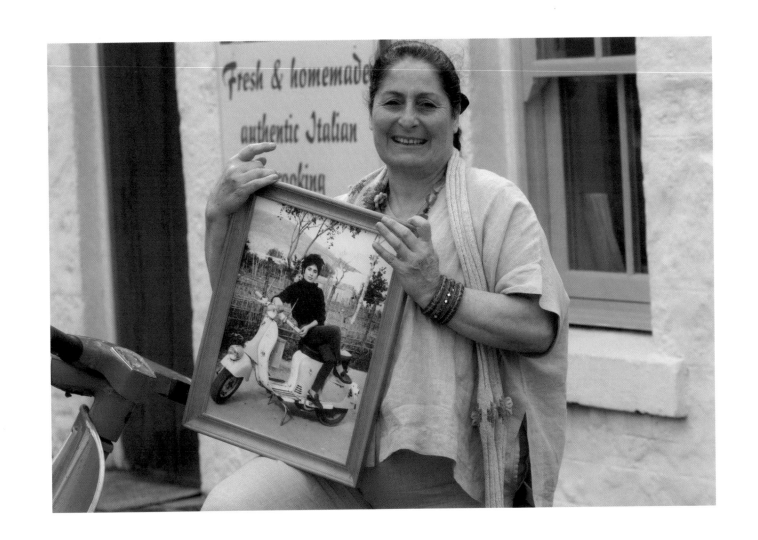

Inside Mediterranea there's a wonderful black-and-white photo on the wall showing a rather glamorous young woman reclining on a scooter. It is Francesca as a teenager in her native Sicily. She happily posed for me with the picture, on the scooter that now sits outside the restaurant in Salen.

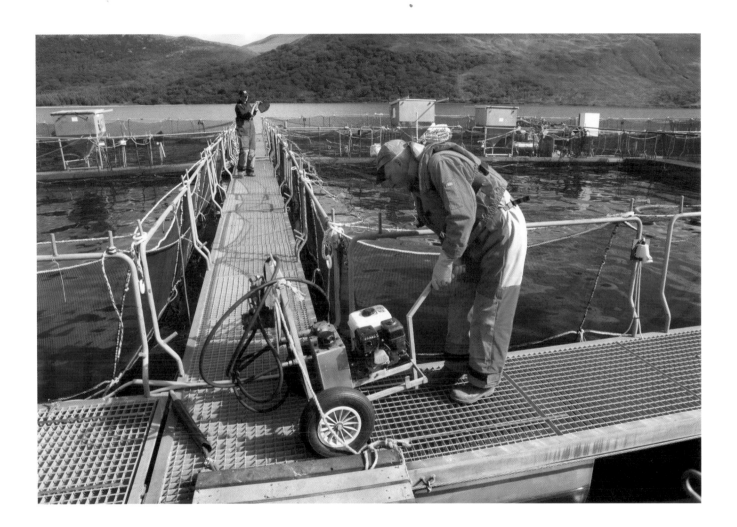

Steve Cordingley tends a pump whilst Andy Duffy labours behind on the 'Scottish Sea Farms' salmon facility on Loch Ba near Knock, Isle of Mull

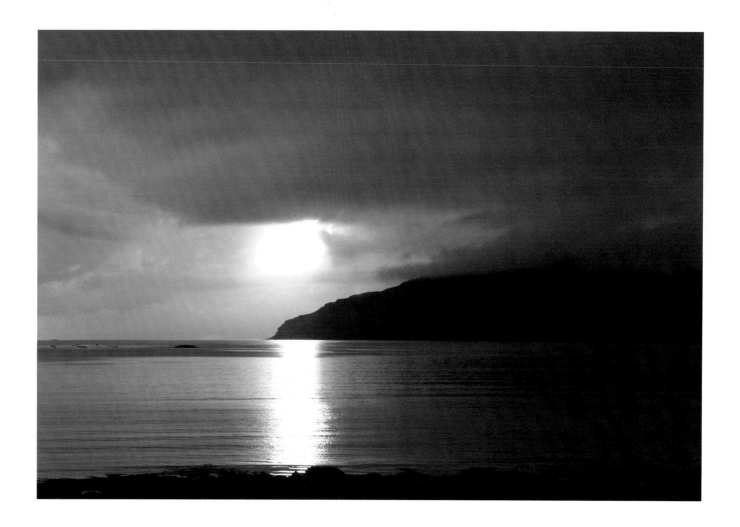

The sun breaks through over Burg, 'The Wilderness', in late evening, reflecting on the calm waters of Loch Scridain, Ross of Mull, after a day of constant cloud and rain

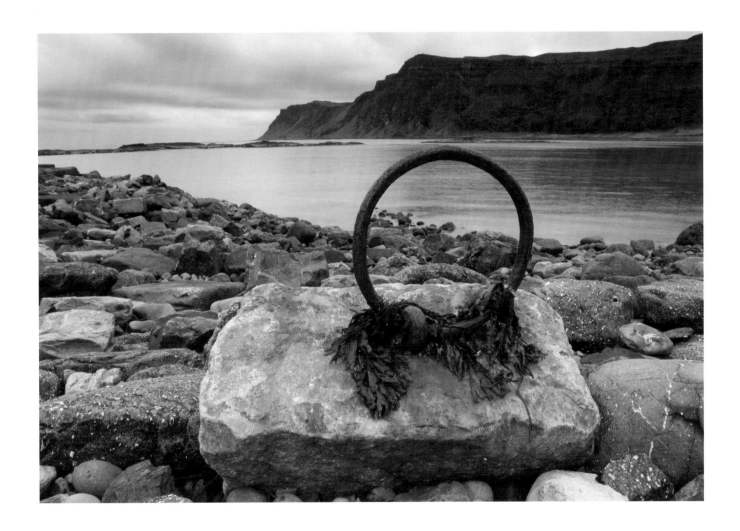

A mooring ring on the shore at Carsaig Pier, Ross of Mull, catches the early morning light

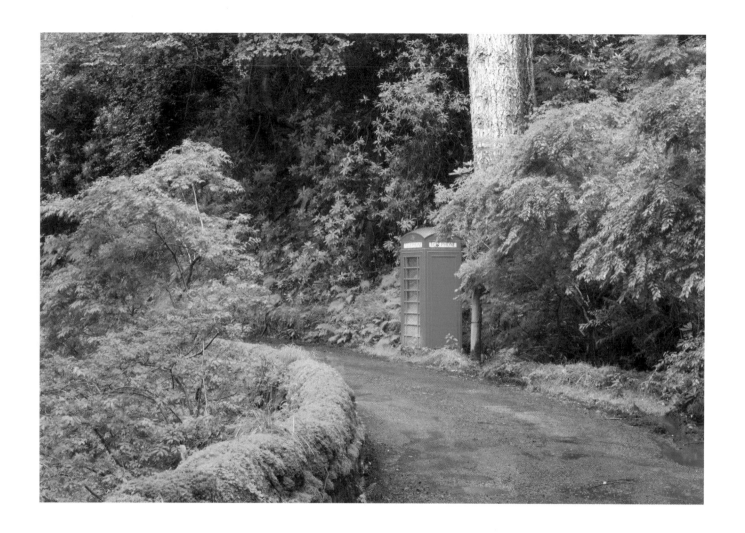

The bright red of the telephone box at Carsaig contrasts with the vibrant summer greenery of this lush and wet sheltered corner, Ross of Mull

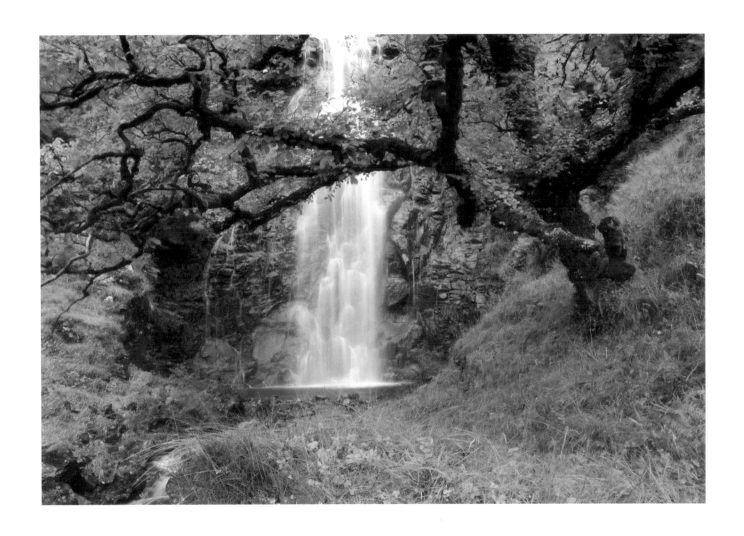

A splendid waterfall cascades down towards Carsaig Bay from the hills around Cnoc a' Bhraghad, surrounded by the verdant green of a damp Highland summer

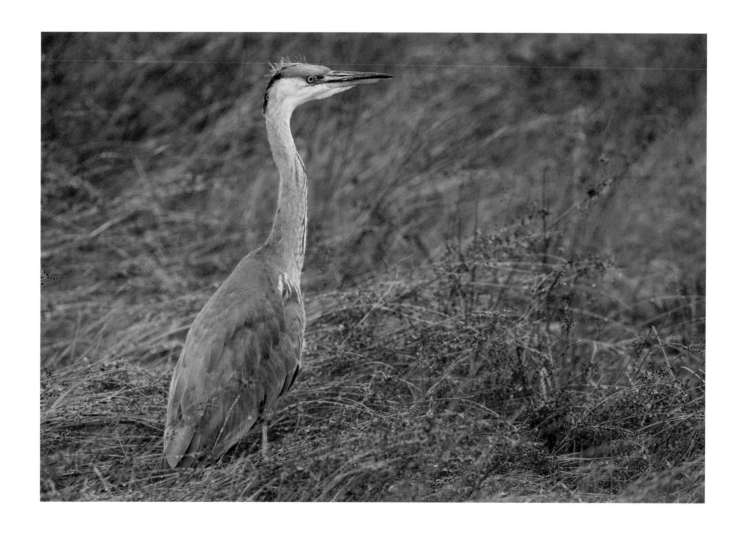

I encountered this immature grey heron stalking patiently in long grass beside Loch Scridain, Ross of Mull, looking for frogs

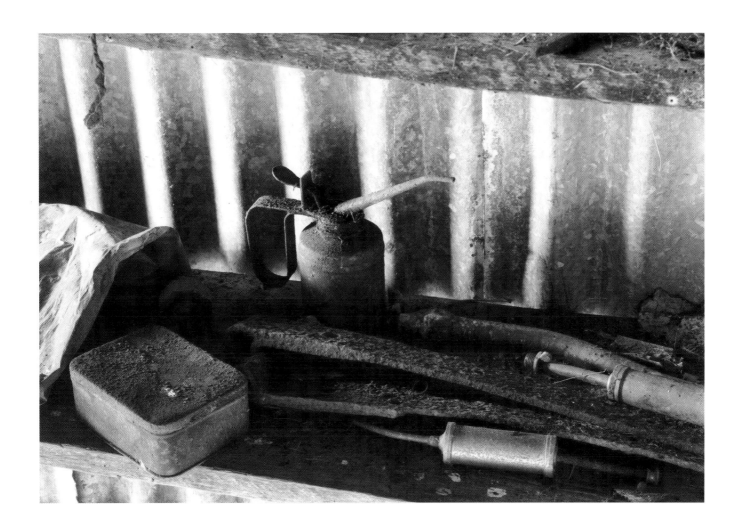

There's an abandoned house on the coast near Gribun on Mull, and opposite it stands a ruined shed, half-fallen and desolate. Inside is a wonderful collection of stuff slowly dissolving in the salty island air.

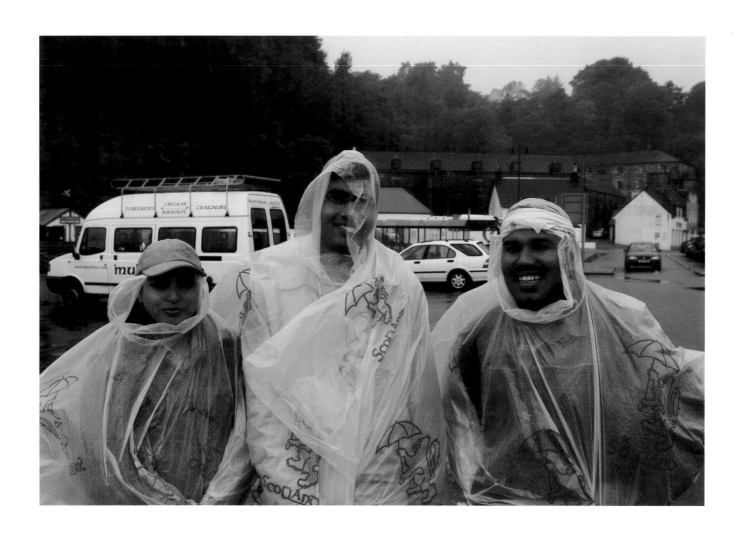

Reena and Viresh Kumawat, and their friend Chandrajeet Yadav, staff in the Royal Bank of Scotland in Edinburgh, on a summer weekend break on Mull on a day of epic rainfall

The Corner Shop in Tobermory has a very colourful van, which is a favourite perch for the many seagulls that ferquent the waterfront

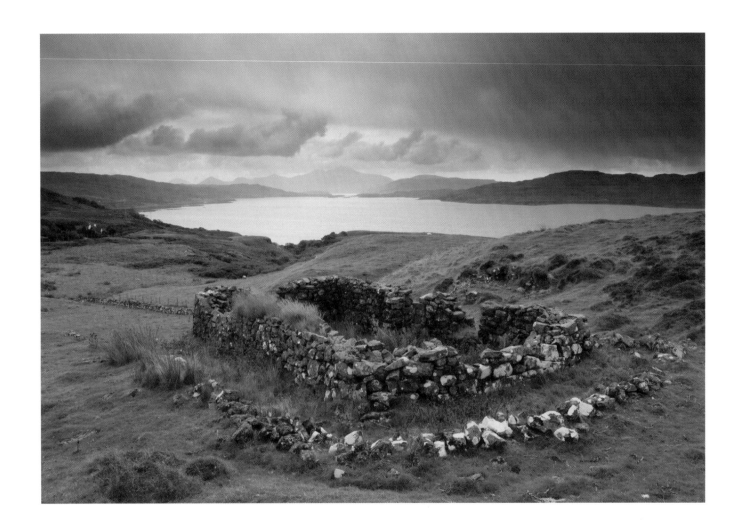

A ruined croft house on the hillside above Tostary, Isle of Mull, looks down on the waters of Loch Tuath, Ben More behind, with the Isle of Ulva to the right

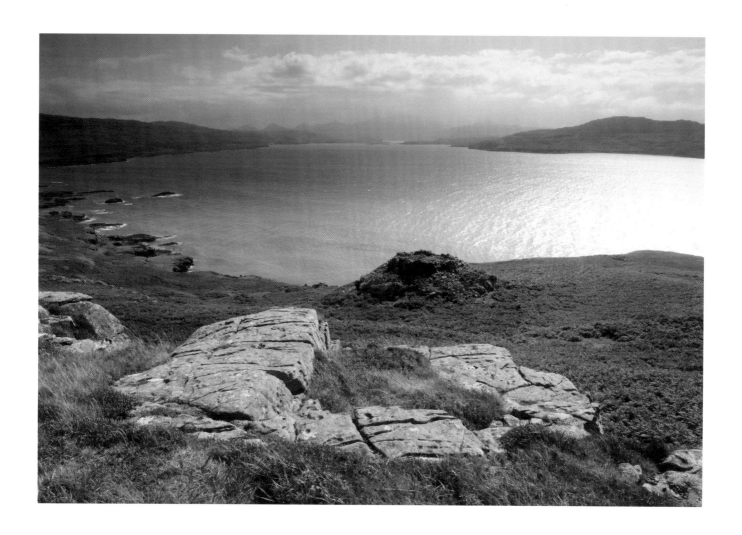

Along the hillside west of Tostary, Isle of Mull, lies Dun Aisgain. This well preserved Iron Age fort occupies a commanding position above Loch Tuath with fine views over Ulva to Ben More.

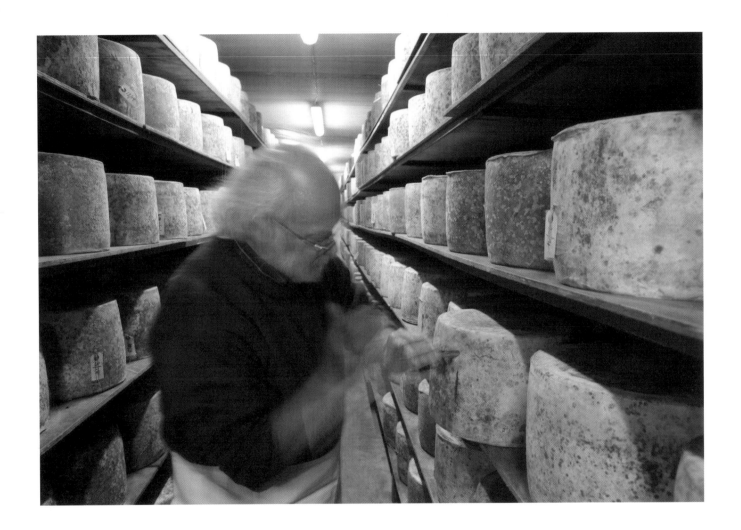

Jeff Reade, cheesemaker, tests his maturing stocks in the cellar of Sgriob-ruadh Farm, near Tobermory, Isle of Mull

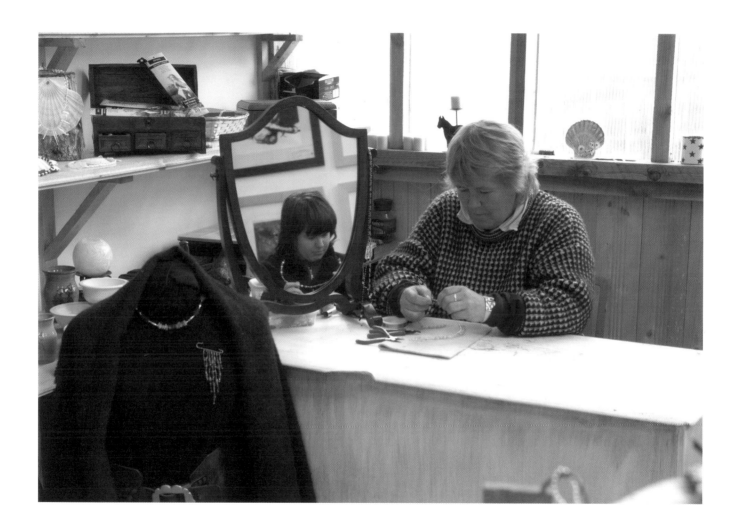

Sam Duffy and her daughter Mickey run a small craft shop at Torlochan, Isle of Mull. The conveniently located mirror allowed me to capture Mickey as she crafted a necklace, off to one side.

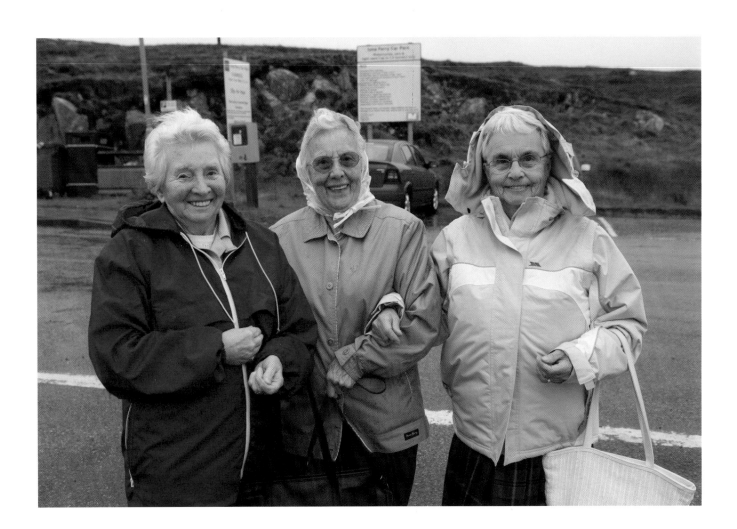

These delightful ladies had made the long journey from Fife to visit Iona, but sadly the ferry was cancelled due to seriously bad weather. They were resigned to the alternative offered by their tour guide, 'The blinking Balamory Experience in Tobermory', as they diplomatically described it!

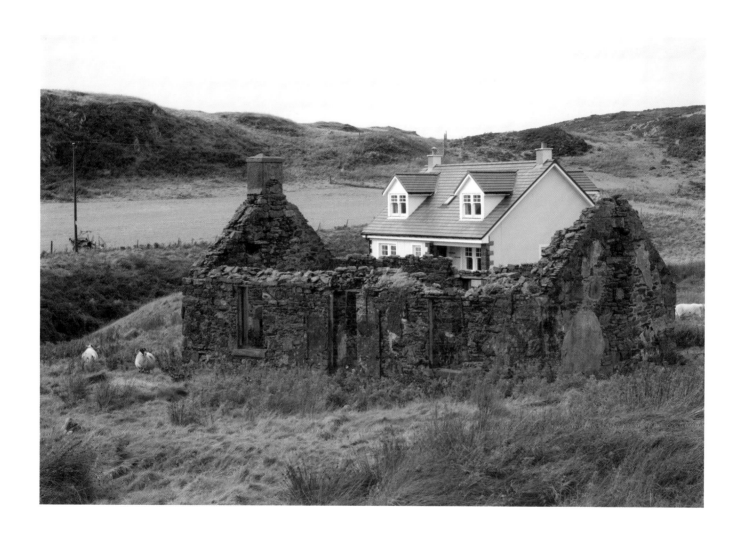

I was struck by the juxtaposition of the new cottage slightly behind, but apparently 'surrounded' by, the crumbling walls of the old house, Ardalanish, Ross of Mull

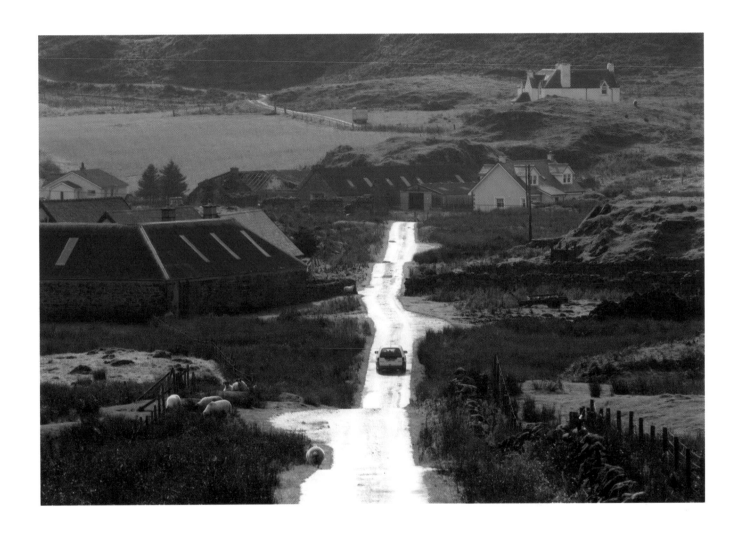

A car traverses the wet and glistening road to Ardalanish from the junction on the road to Uisken, Ross of Mull

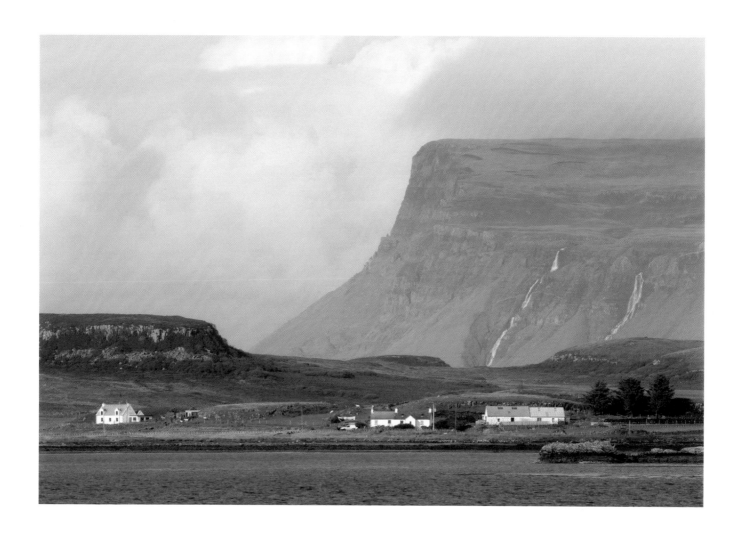

A clearing summer day after torrential rain reveals a lovely view across loch na Lathaich, over the houses at Lower Ardtun to waterfalls tumbling off the rugged cliffs of The Wilderness on Burg, Ross of Mull, near Bunessan

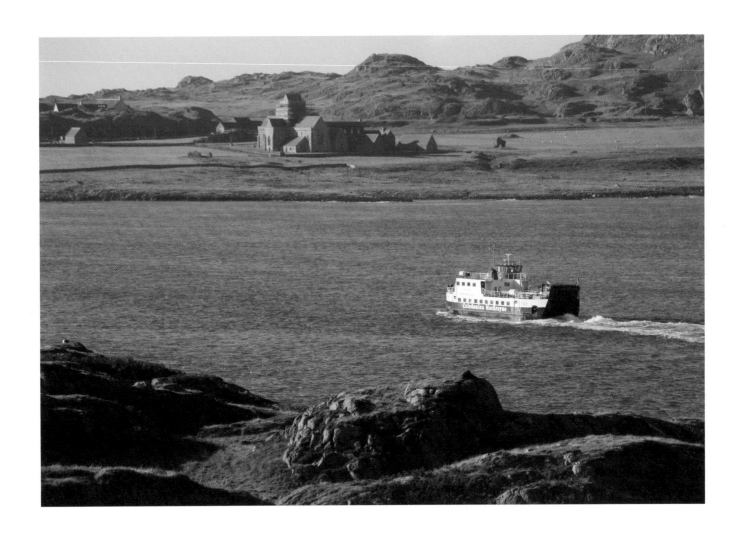

Calmac ferry Loch Buie crosses the Sound of Iona from Fionnphort to Iona. Iona Abbey is visible in the background.

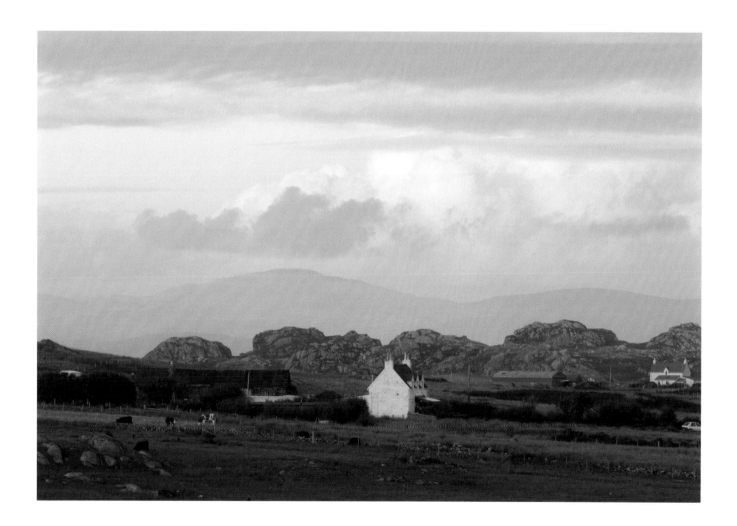

Houses at Drumbuie near Creich, with the rough outcrop of Cnoc-na-ciste, Ross of Mull, near Fionnphort

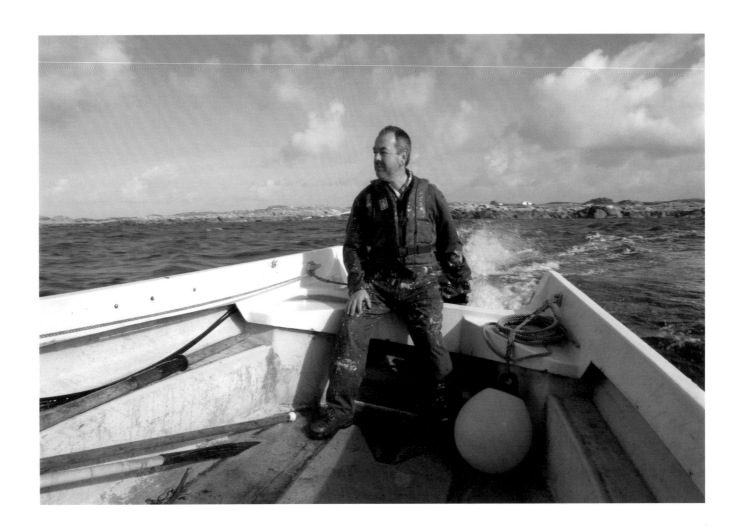

Erraid resident Paul collected me from Mull and ferried me across to the island. Everything the island needs is brought in this way.

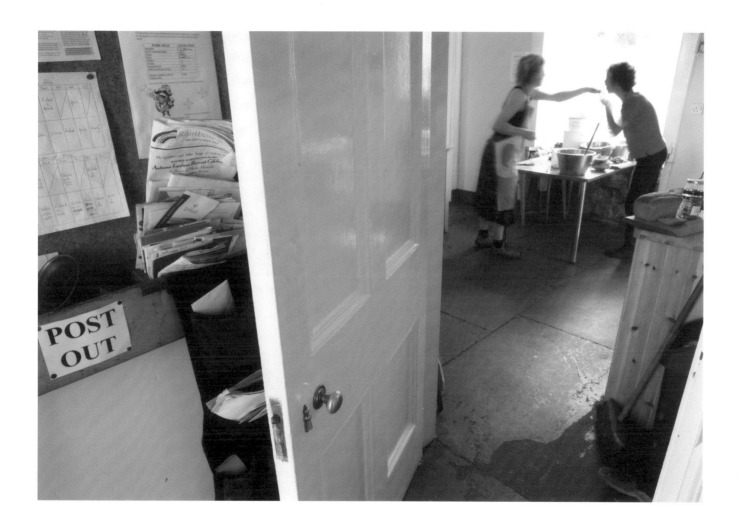

Sam, one of the island's guests, whose duties on this particular day included making the lunch, shares a taste with her mother

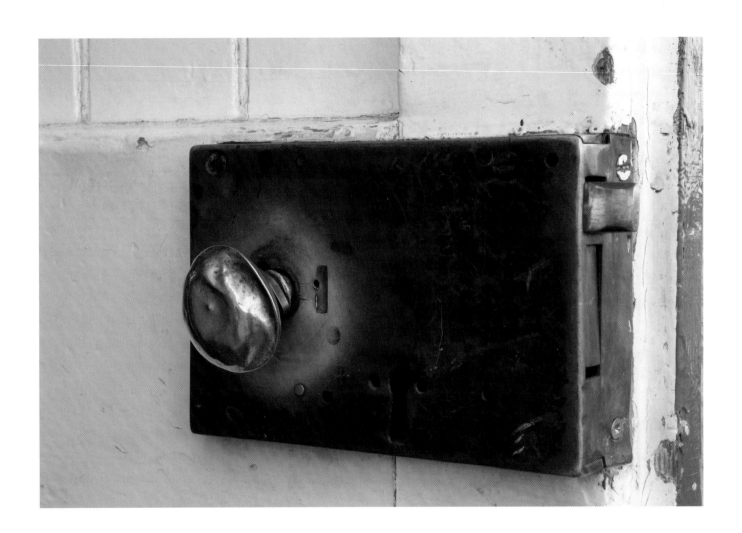

The well burnished doorhandle to the kitchen and dining room indicate the amount of use this particular door has enjoyed (Erraid)

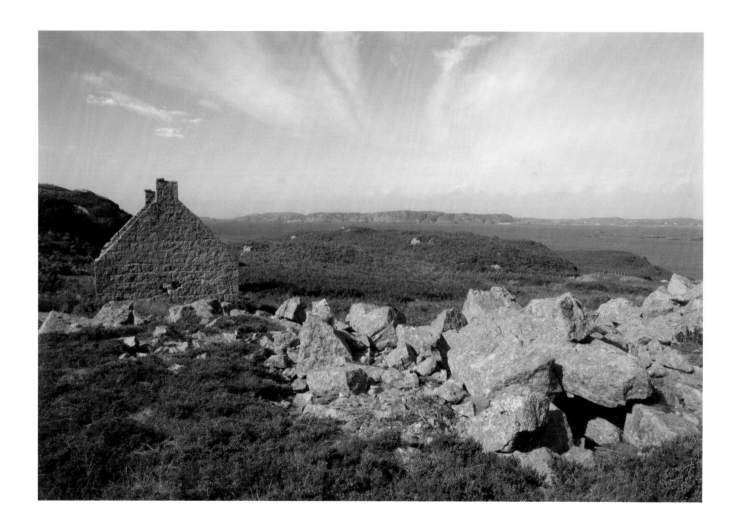

The gable of a ruined cottage on the north side of Erraid and the view north-west towards Iona

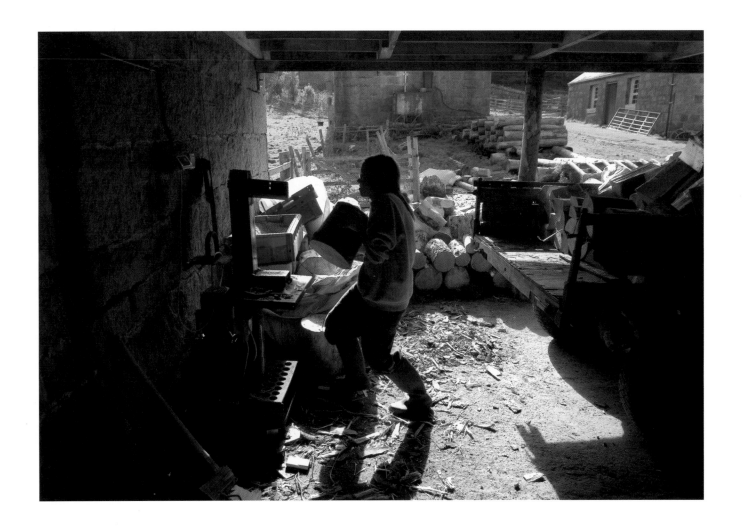

Vrede, one of the long-term residents on Erraid, hoists a log onto the splitter for firewood

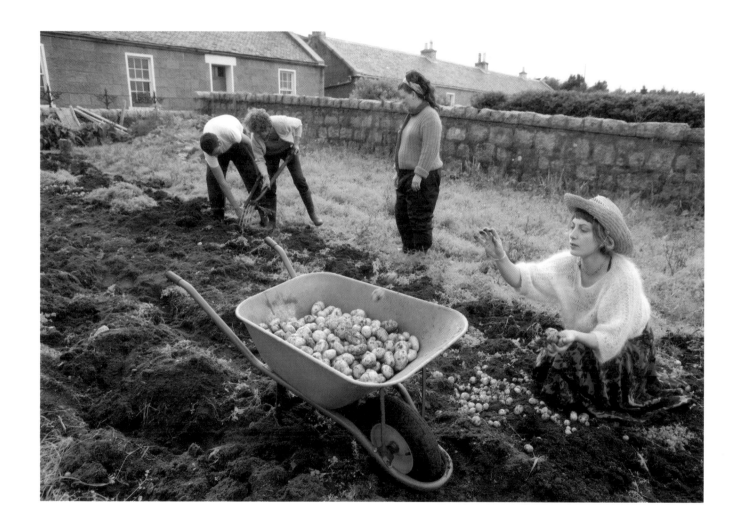

Residents tend the vegetable garden in front of the stoutly built cottages. Erraid was, until 1967, the lighthouse shore station for Skerryvore and Dubh Artach lighthouses.

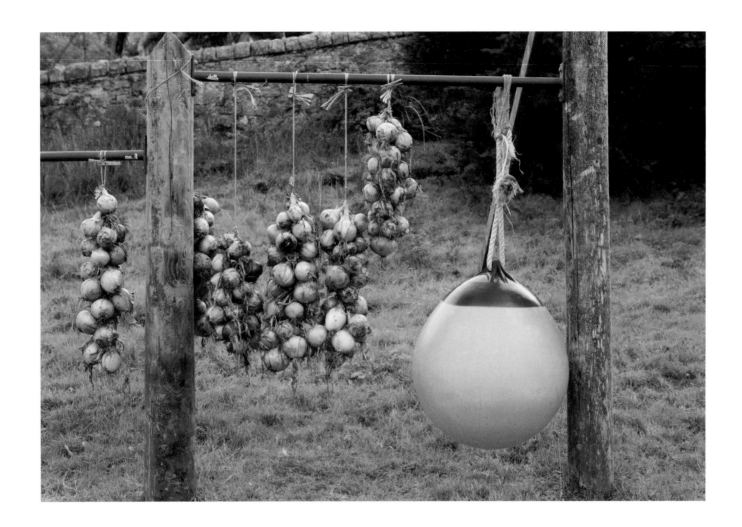

Onions and a mooring buoy hang in the gardens behind the cottages on Erraid

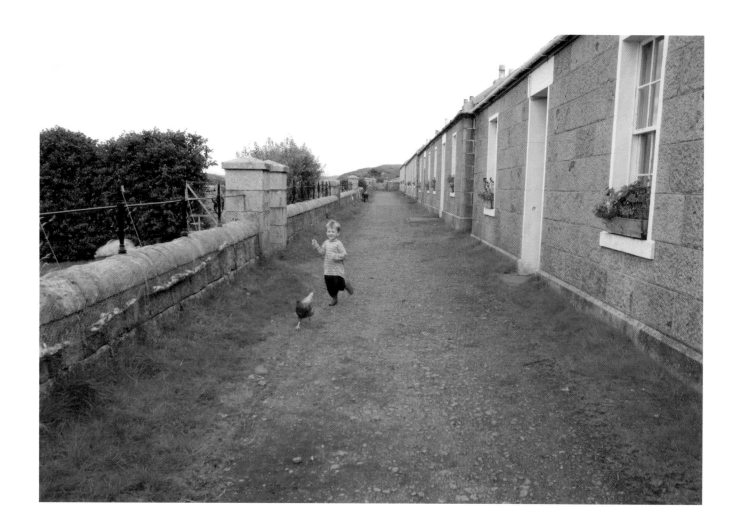

Erraid resident Josh chases his hen along the 'street' in front of the cottages

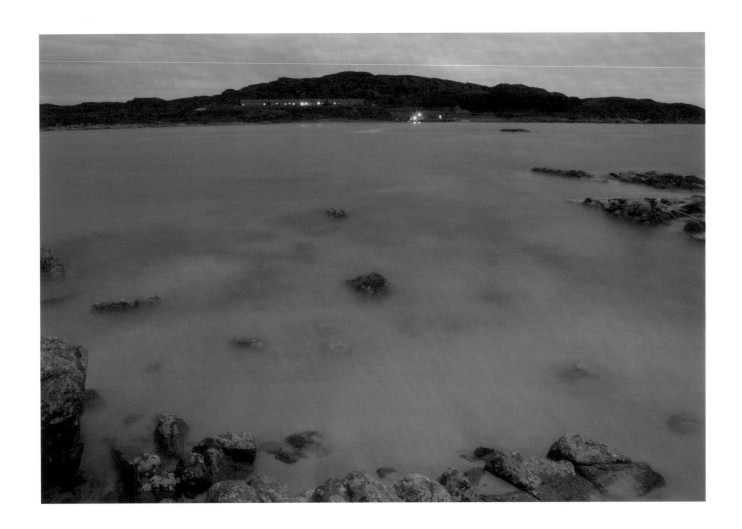

The lights of Erraid sparkle across An Caolas in the twilight of an autumn evening

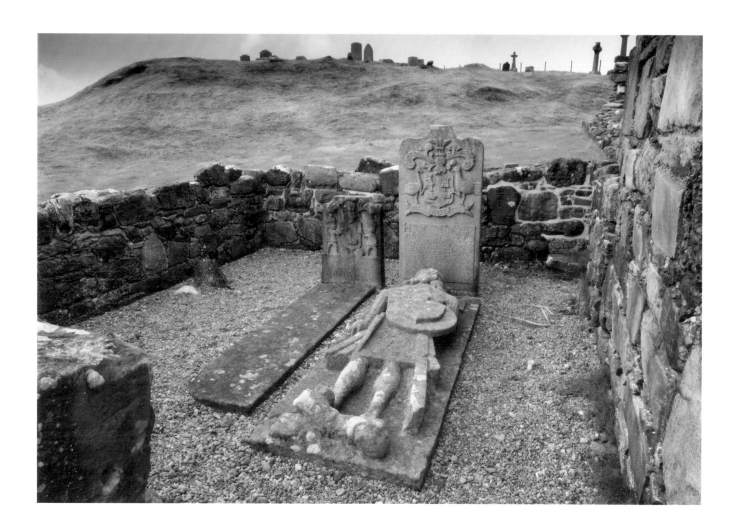

The elaborately carved tomb of Donald MacLean, showing him in full regalia of kilt, sword and shield, with his dog at his feet, lies in the small walled section to the south side of the ruined chapel on Inchkenneth

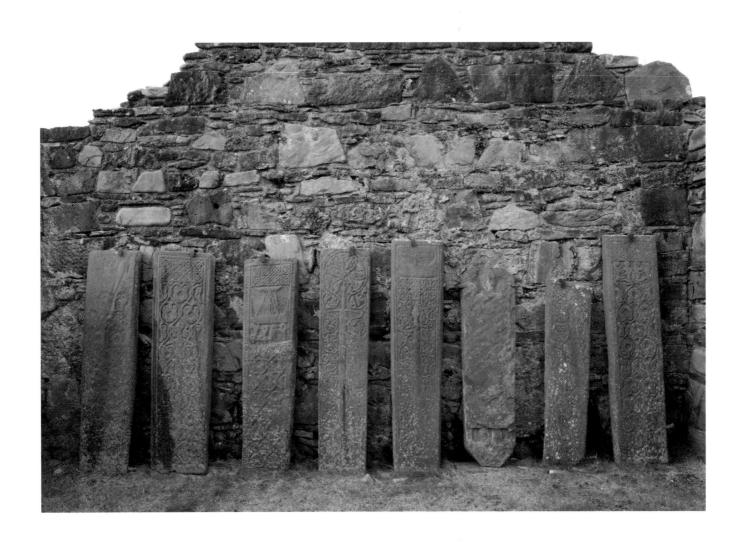

There is a fine collection of grave slabs inside the ruins of the chapel on Inchkenneth, which is in the care of Historic Scotland.

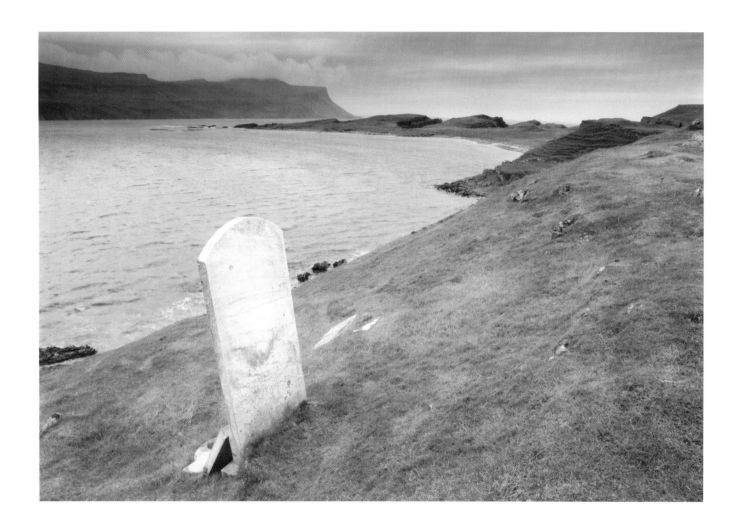

A lone gravestone with the long curve of Inchkenneth and the cliffs of Ardmeanach behind

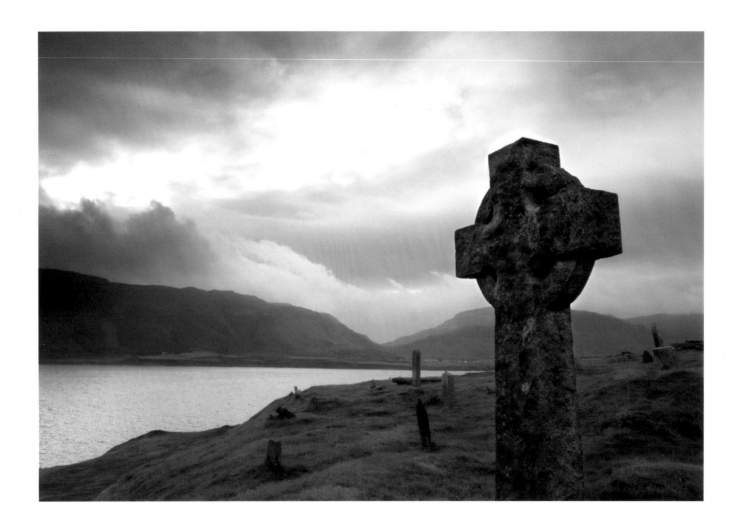

A fine Celtic cross with approaching 'weather' over the hills of Gribun

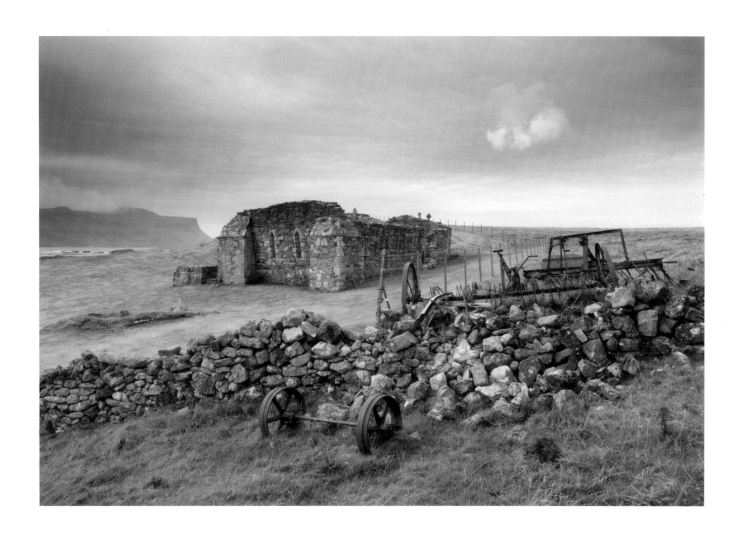

The ruins of Inchkenneth Chapel, and some abandoned farm machinery slowly rusting in the salty air

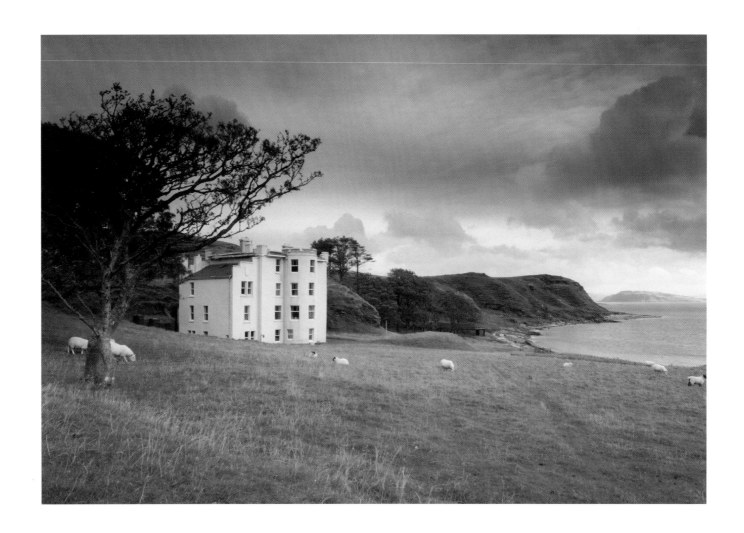

Inchkenneth House, along with the island, was once the property of the Mitford family (Lord Redesdale), and has a long and interesting history. It is no longer permanently inhabited.

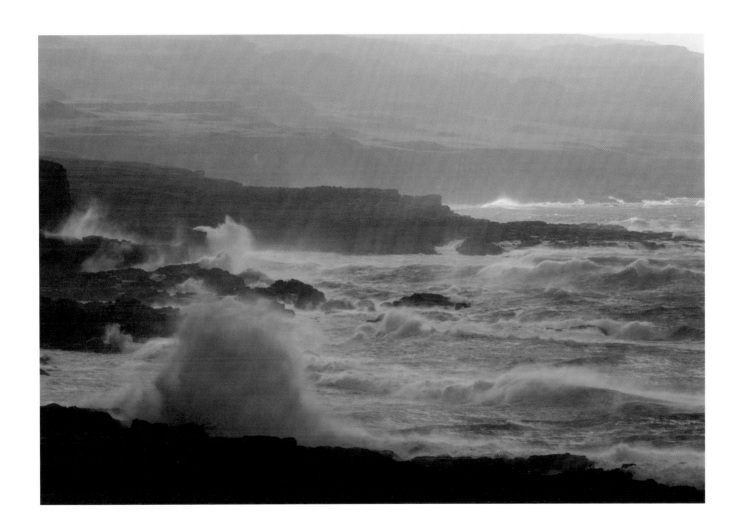

Hurricane-force winds batter the coast at Calgary Bay, Calgary, Isle of Mull

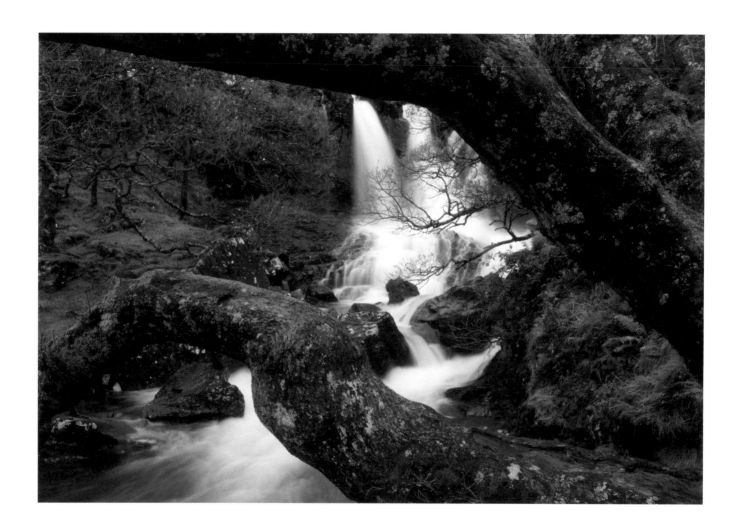

Allt an Eas Fors tumbles down towards the sea on a drizzly overcast morning of biting November cold

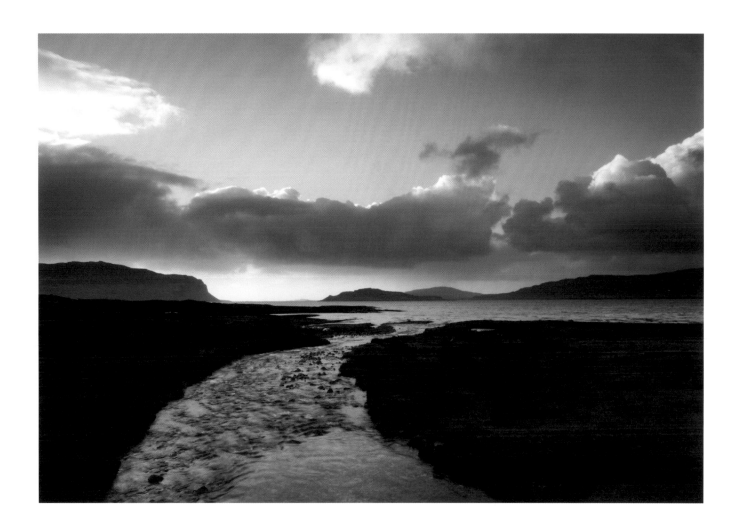

Eorsa (Horse Island) nestling in Loch na Keal on a bitterly cold winter evening, with the light from the cool blue sky reflected in the curve of Abhainn na h-Uamha

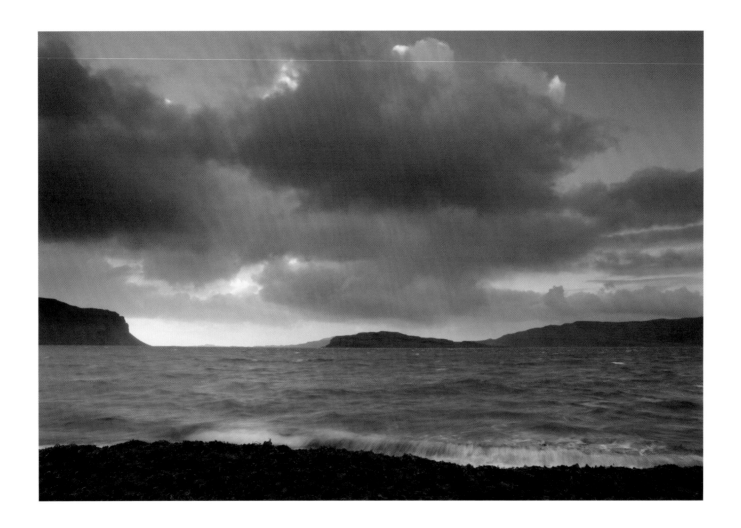

Eorsa (Horse Island) nestling in Loch na Keal on a cold winter evening

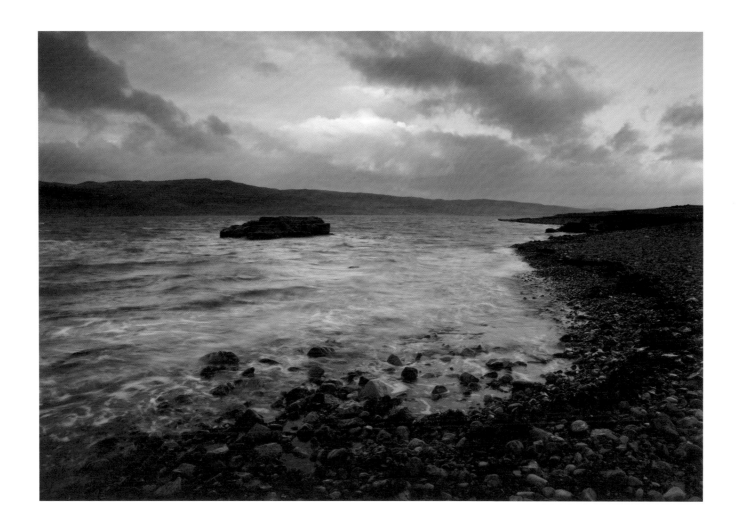

The sun setting on a cold winter night illuminates the clouds over Loch na Keal, near Dhiseig, Isle of Mull

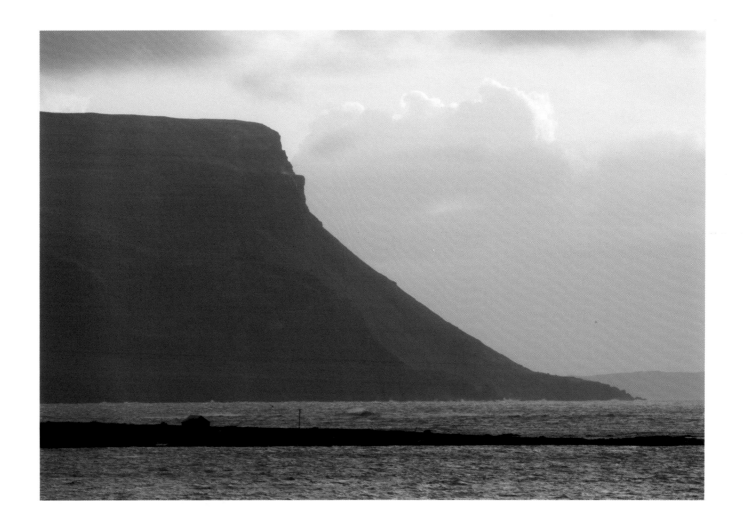

The cliffs of Ardmeanach tower over the small hut on Rubha Baile na h'Airde at Gribun, Isle of Mull

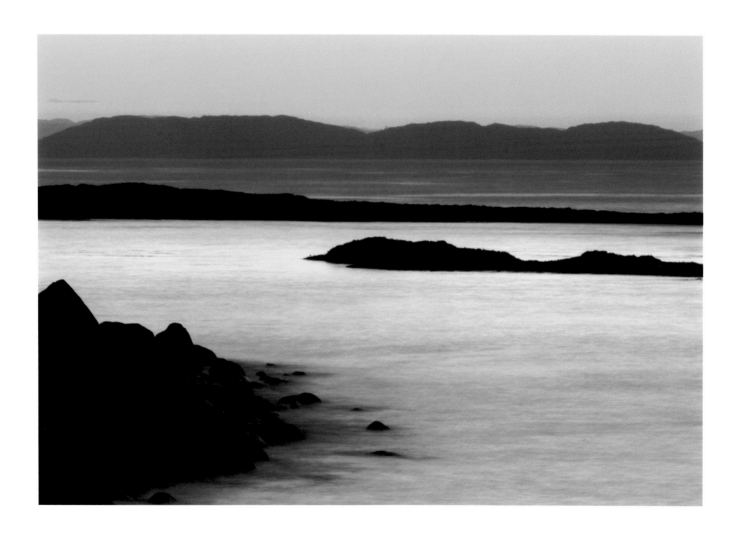

A perfect winter morning of calm seas and wonderful light, looking east from Carsaig Bay, Isle of Mull

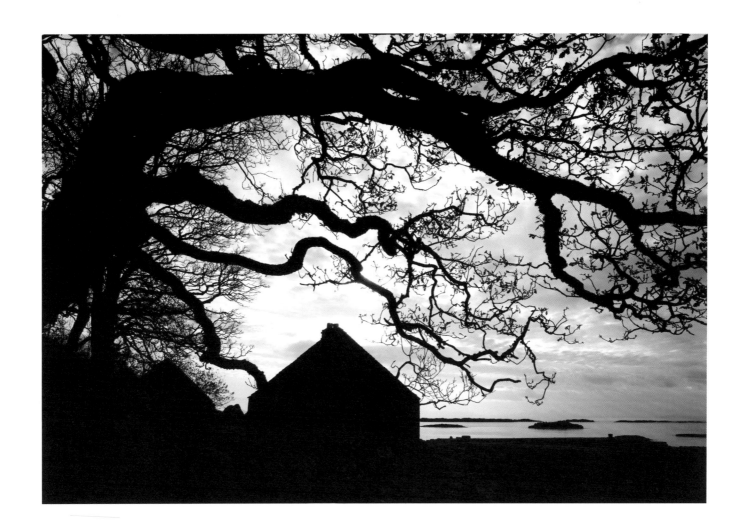

The boathouse beside Carsaig Pier, Isle of Mull, dramatically silhouetted against the morning sky on a perfectly calm winter's day

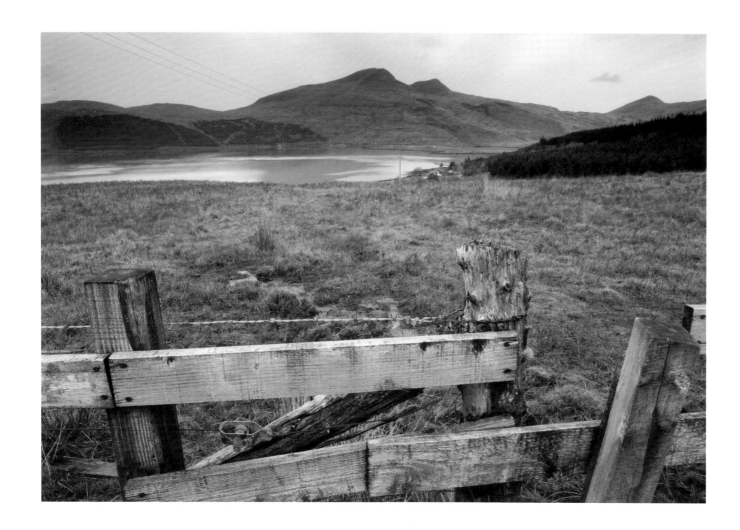

Ben More viewed across Loch Scridain from the slopes above Pennyghael, Isle of Mull

A perfectly still day after a fierce November storm the previous day reveals the more tranquil side of Loch Scridain, looking west from near Pennyghael, Isle of Mull

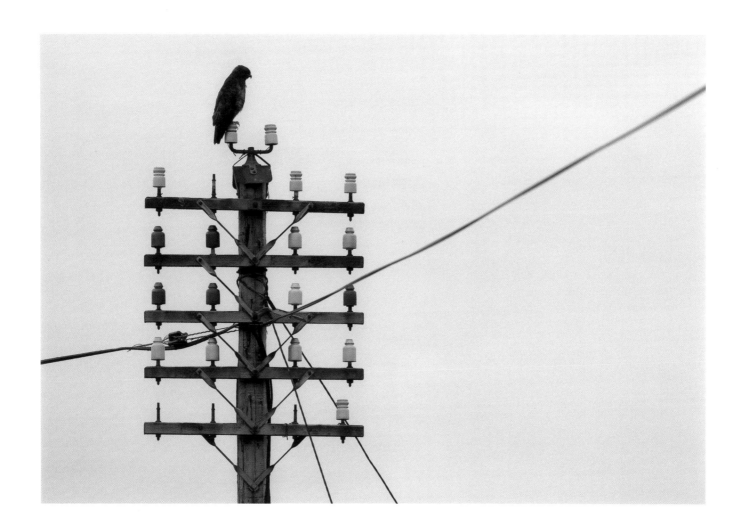

An ever-watchful buzzard perches hopefully on a roadside pole near Pennyghael, Isle of Mull

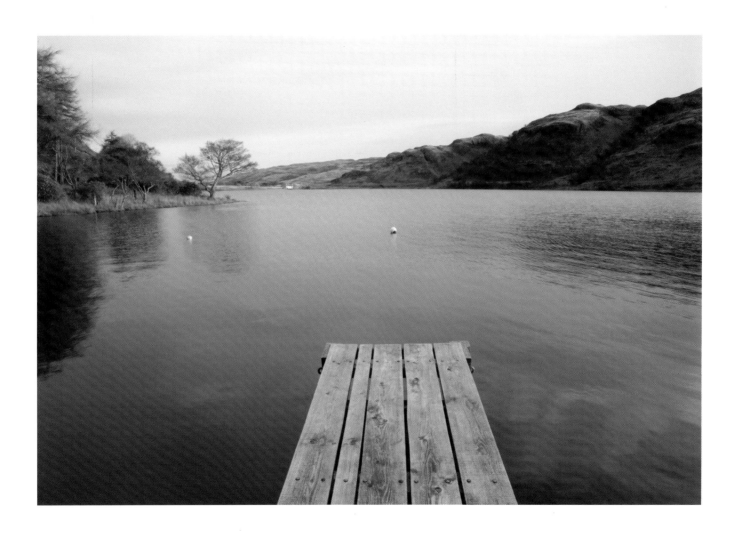

A small pier just into the still waters of Loch Uisg near Kinlochspelve, Isle of Mull

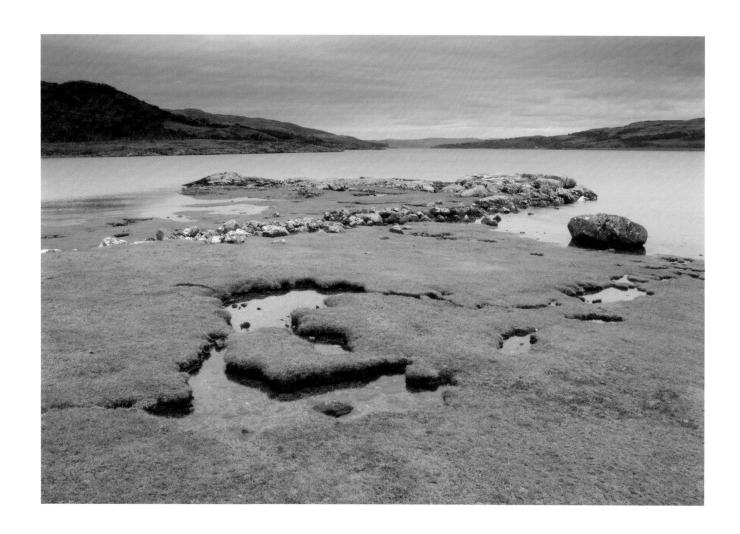

I was intrigued by this pattern of small ponds on the shore at Loch Spelve near Fellonmore, Isle of Mull, as it was an almost perfect replica of the shape of Mull, but reversed

Warm and inviting light spills out from the Salen Hotel, Isle of Mull, as the local lads enjoy a game of darts

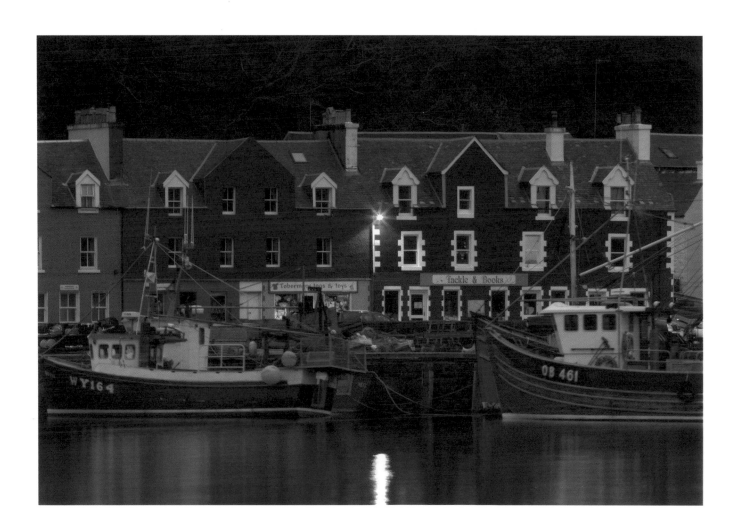

Tobermory village and harbour in winter twilight on a calm evening

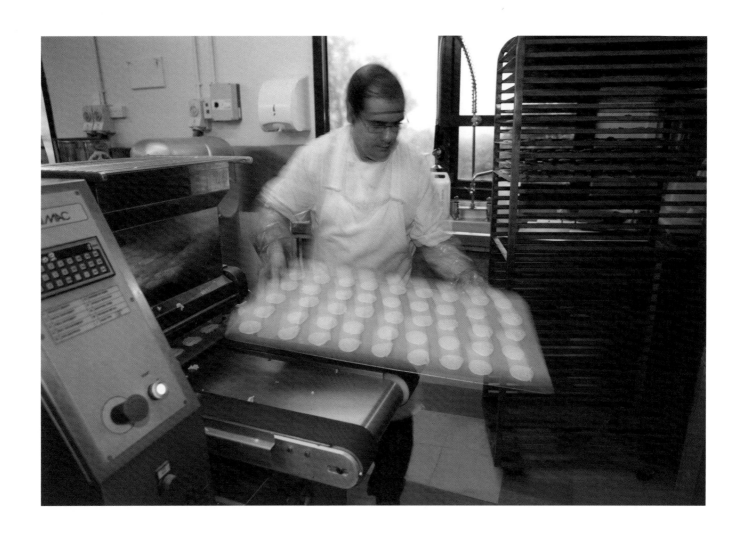

Island Bakery makes terrific organic bsicuits which are exported all over the world from this small facility near Tobermory. Baker Ricardo Raposo and his wife moved from the Azores to work on Mull.

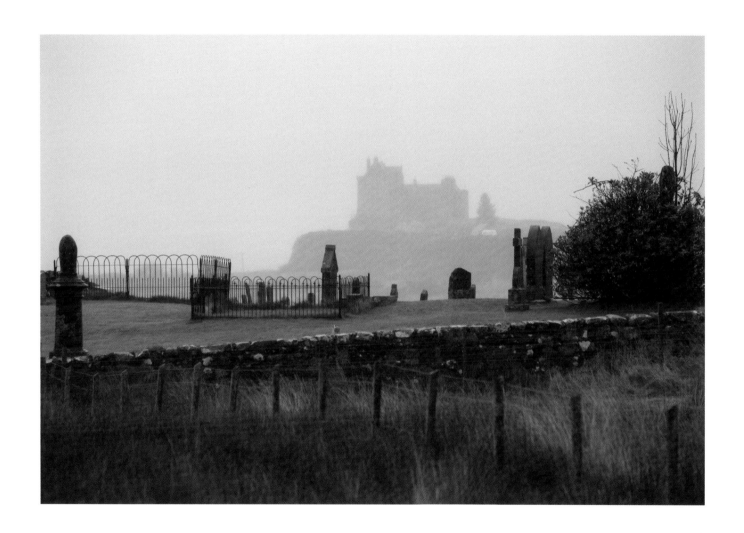

Duart Castle looms through the mist and rain of a foul winter day behind the graveyard at Druimsornaig. The castle, now a clan centre and home of the chief of the Clan Maclean, occupies a commanding position overlooking the Sound of Mull.

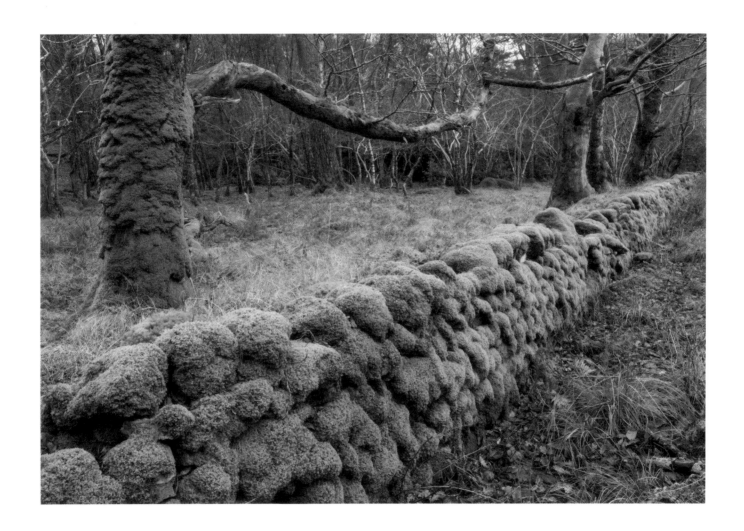

Moss covers a dyke and tree trunks along the roadside between Gruline and Knock on the shore of Loch na Keal, Isle of Mull

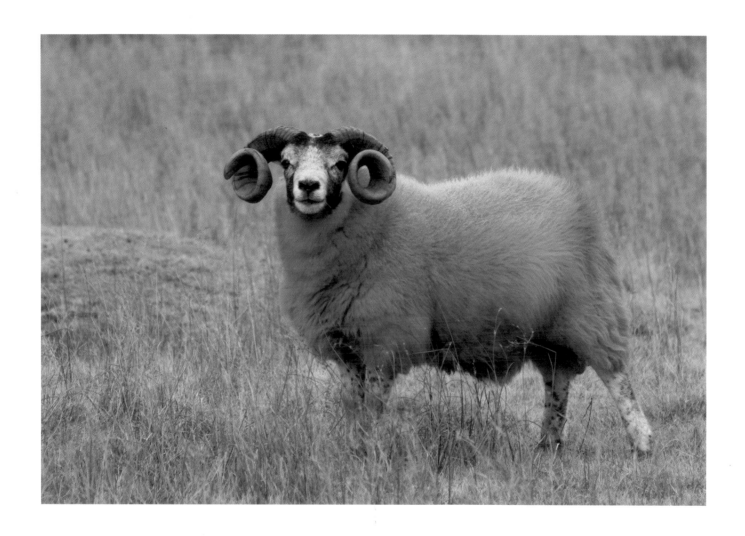

A fine tup scrutinizes the photographer on the side of Loch na Keal on a winter day

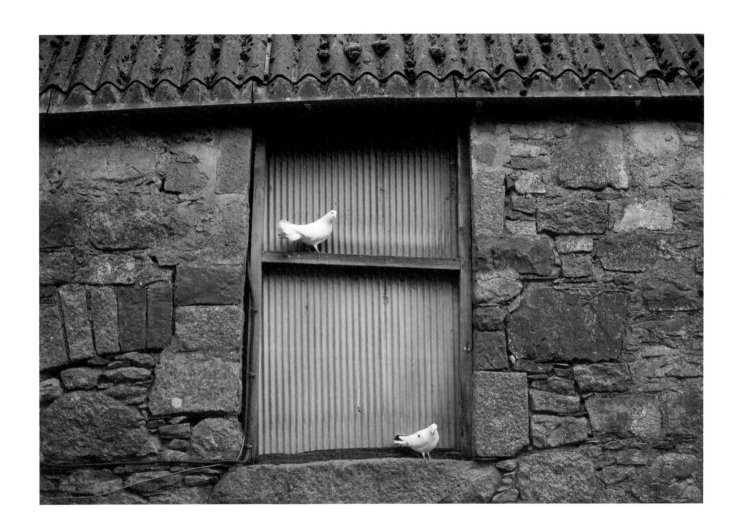

Donald MacLean at Knock Farm has a fine collection of doves, which enjoy a variety of perches on the numerous buildings that make up the farm

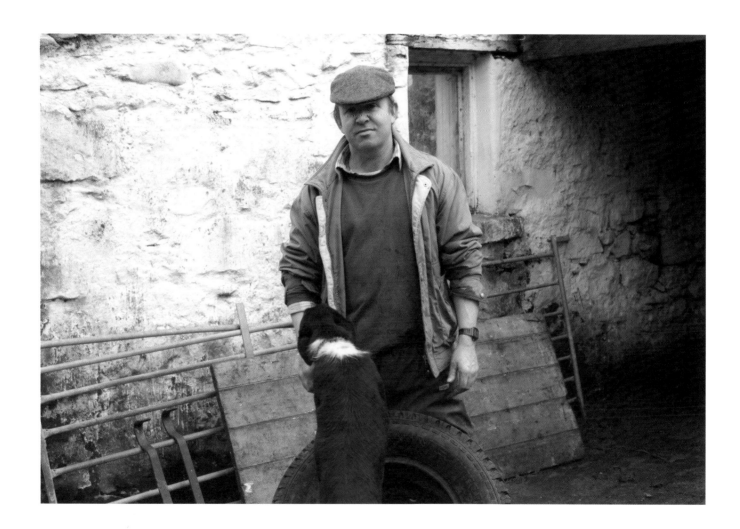

Donald MacLean mending a tyre from the Land Rover, Knock Farm, with help from one of his many collies

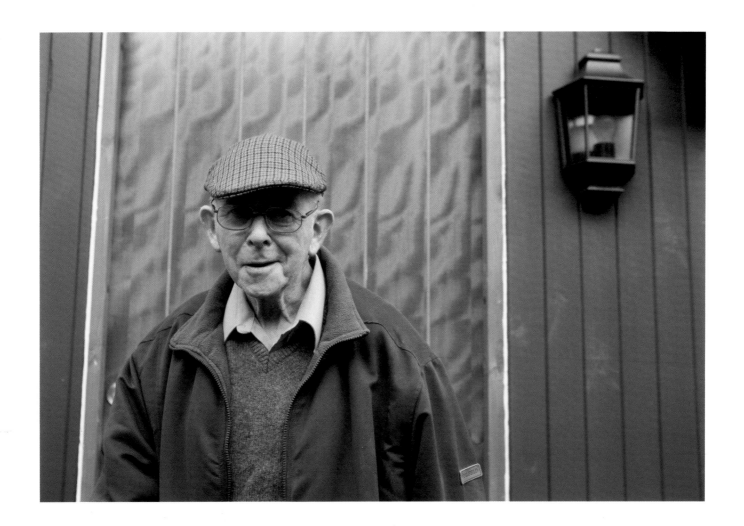

Lachlan MacLean stands proudly outside the fine front door of his newly built cottage at Knock Farm

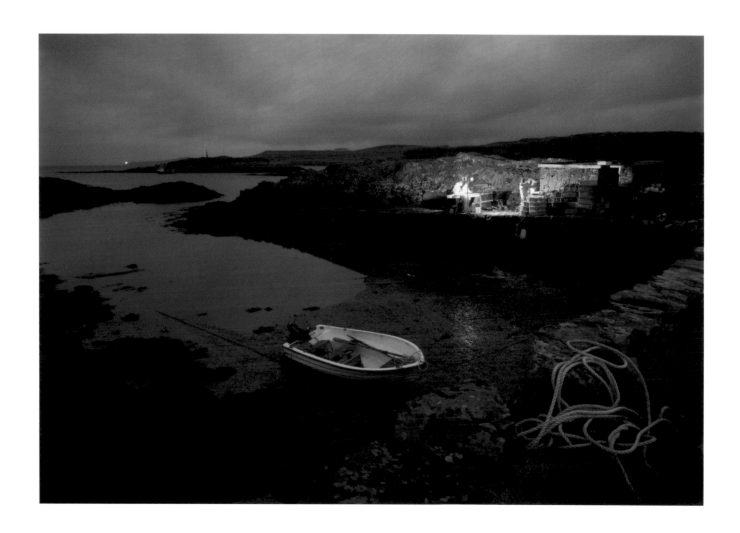

Nick and Kenny Turnbull, Ronan Martin and Cohn Morrison sort and pack their catch of crabs for export, on the pier at Croig in pre-dawn December light. The lighthouse at Ardnamurchan blinks in the left of the frame.

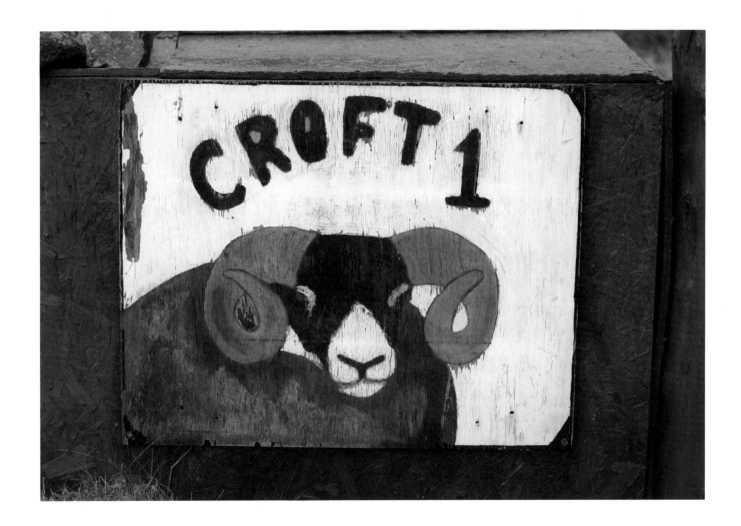

Croft sign on the roadside near Loch Tuath

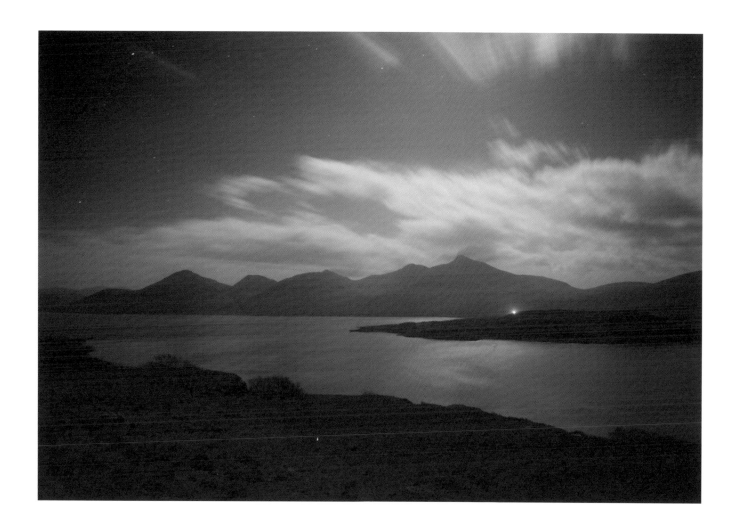

Clouds scud across a starlit sky on a frosty moonlit December night, above Loch na Keal. The light glinting over the edge of Eorsa (Horse Island) is from the house at Dhiseig.

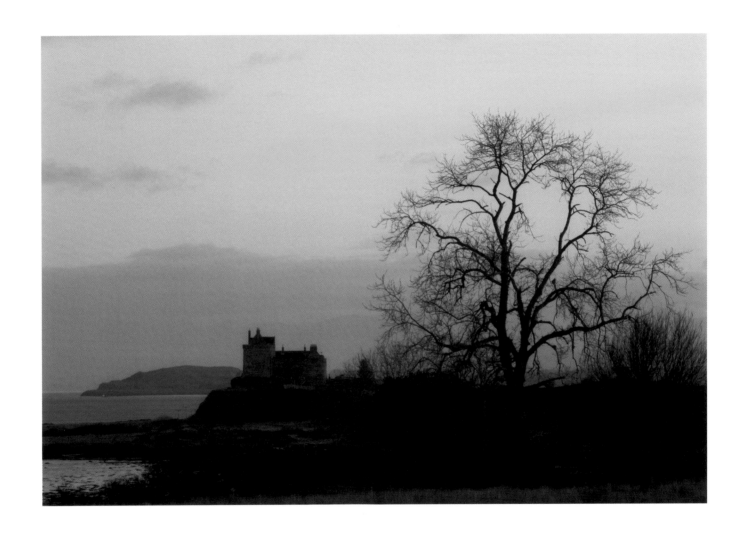

Duart Castle, seat of the Clan Maclean, catches the first pink light of a winter dawn over the Sound of Mull

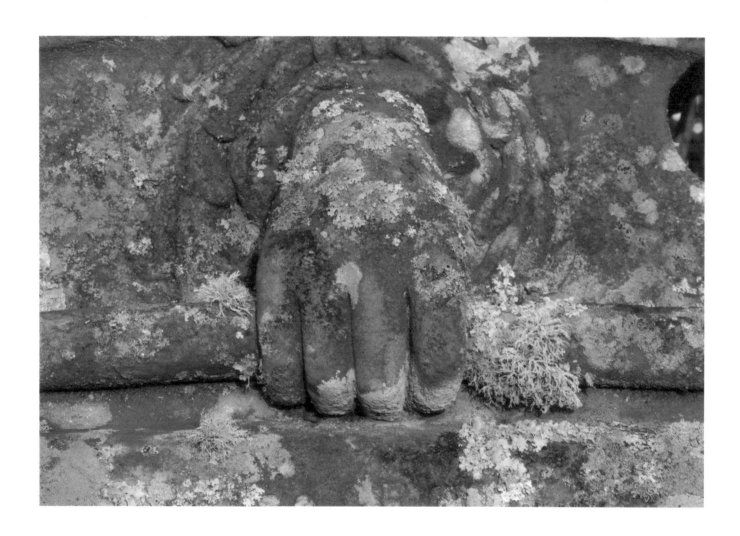

Detail of a gravestone in early morning light in the graveyard near Druimsornaig, Duart Point

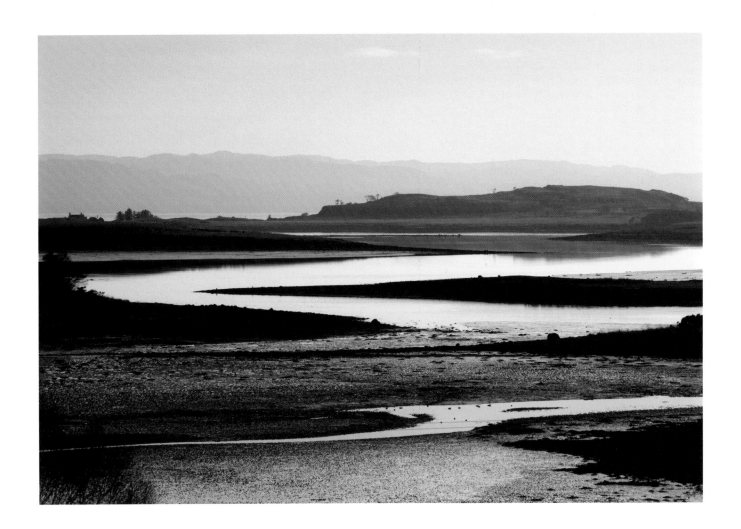

Low tide and low winter light reveal lovely patterns of land and water in Loch Don

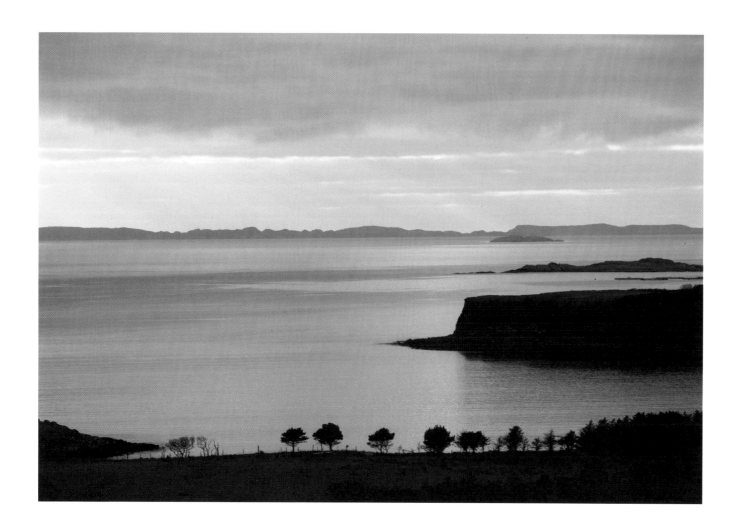

View from Acharonich on Mull across Ulva, the islets of Geasgill Mor and Erisgeir to the Ross of Mull on the horizon, in late afternoon winter light

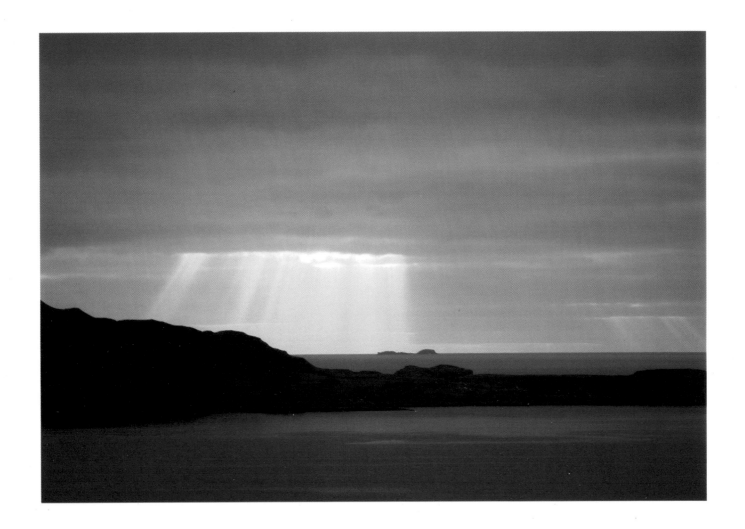

Shafts of light on a winter afternoon spill down onto Staffa on the western horizon behind the low north-west corner of Gometra